Physician Avocations

Photographs and Poetry
Published in
Baylor University Medical Center Proceedings

Celebrating publishing
BUMC Proceedings
for a third of a century.

Cover photograph credits:
Front cover: Rolando M. Solis, MD.
Back cover, top left and right: Jed Rosenthal, MD.
Back cover, bottom left and right: Gregory Dimijian, MD.

To request additional copies, contact
BUMCProceedings @bswhealth.org.

Copyright © 2021, Baylor University Medical Center.
The contributors retain the rights to their work.

All photographs and poems were originally published in *Baylor University Medical Center Proceedings,* the peer-reviewed medical journal of Baylor Scott & White Health.

ISBN 978-1-63760-295-9

Table of Contents

Preface ... v
Alejandro C. Arroliga, MD .. 1
Gregory G. Dimijian, MD .. 7
Baron L. Hamman, MD .. 11
Jay Hoppenstein, MD ... 13
Amanullah Khan, MD, PhD ... 18
Terry C. Lairmore, MD .. 32
John L. Manning, MD .. 33
Jeffrey Michel, MD ... 35
William L. Rayburn, MD .. 37
Maruf A. Razzuk, MD ... 39
Jed Rosenthal, MD ... 41
Rolando M. Solis, MD .. 47
Barry Uhr, MD ... 65

Preface

Early in the tenure of Dr. William C. Roberts as editor in chief of *Baylor University Medical Center Proceedings,* he became aware of physicians' many creative talents—often through the interviews he conducted and published. He invited some to contribute their pieces to the journal. We called this feature "Avocations." For the first decade, only a dozen or so Avocations were published. Later, more physicians began to participate, and most issues featured at least one Avocation contribution. Although paintings and poems have been featured, most Avocations are photographs—ranging from microphotography to nature and animal photos to pictures of historic places.

This volume was suggested by Dr. Alejandro Arroliga, Baylor Scott & White Health's chief medical officer (and a contributor himself). He has been a key supporter of the journal. We are pleased to present this volume to highlight the many talents of our physicians.

Alejandro C. Arroliga, MD

Dr. Arroliga is executive vice president and chief medical officer of Baylor Scott & White Health. He has published images in Proceedings *since 2016.*

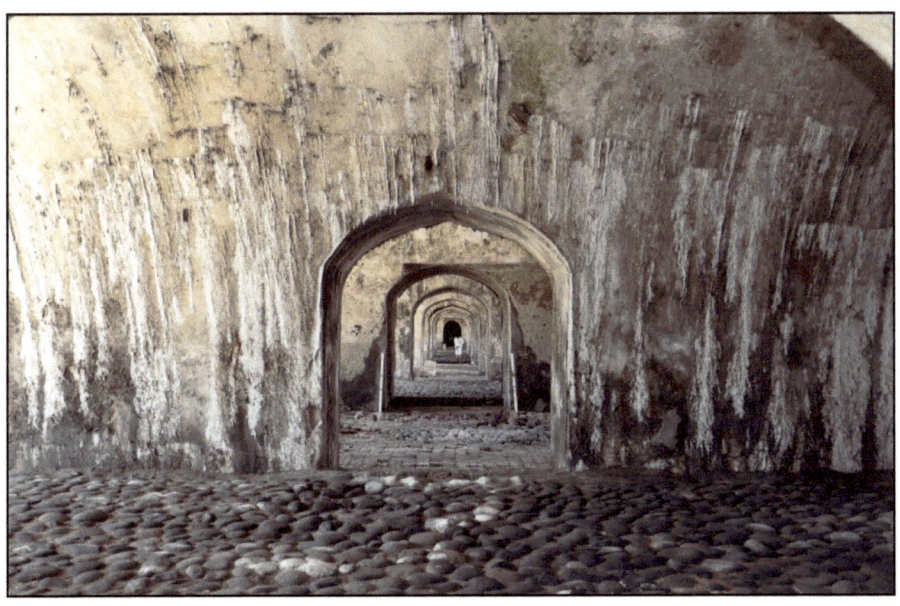

Fort of San Juan de Ulúa built in the 14th century, Veracruz, Veracruz, Mexico.

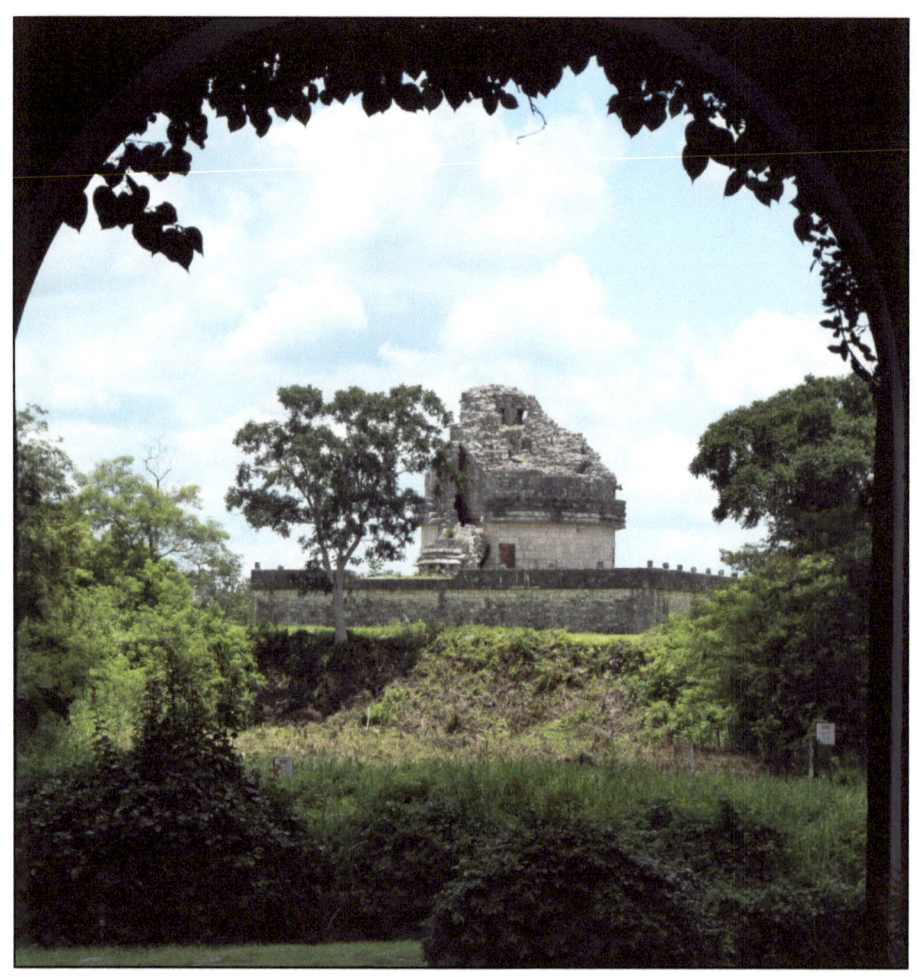

El Caracol, or Observatory, Yucatan, Mexico. This building, which dates to 900 to 1000 AD, is within the structure of the citadel called Chichén Itzá. The Caracol ("snail" in Spanish) got its name from the shape of the inner staircase and is believed to be an ancient observatory. The building may have symbolized the deity Quetzalcoatl and is considered a "calendar in stone" since it displays significant astronomical events. The directions of the faces of the lower and upper platforms point to horizon events involving the planet Venus and the sun.

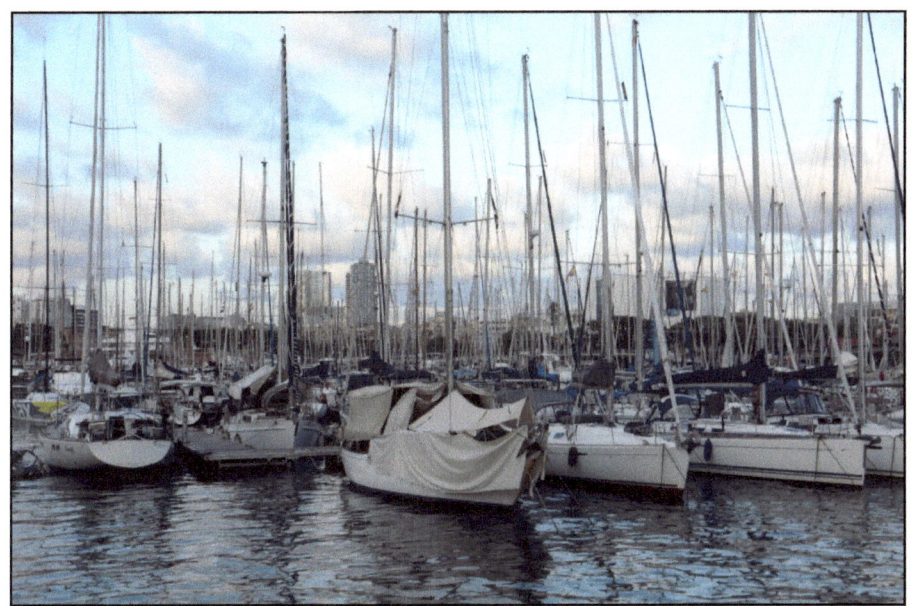

Port Vell (Old Harbor) is a waterfront harbor in the port of Barcelona, Catalonia, in Spain. The port is at the end of the famous boulevard La Rambla.

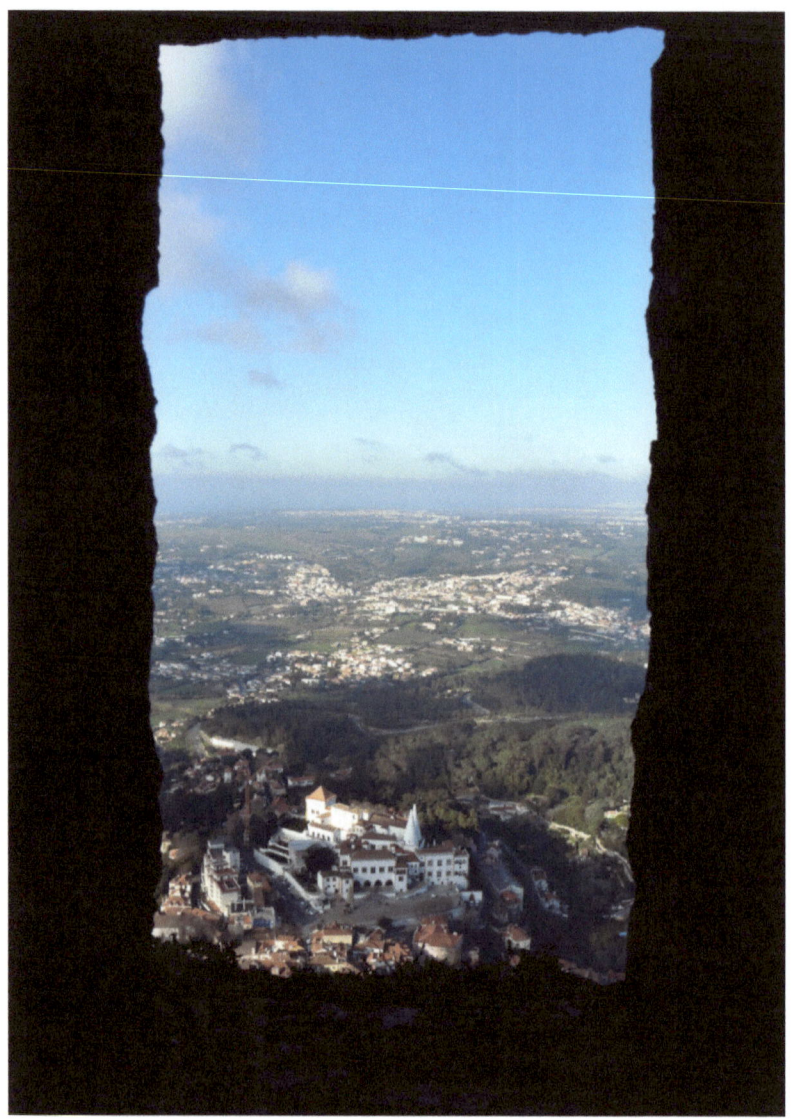

Photo taken from the Castelo dos Mouros (Castle of the Moors) in Sintra, near Lisbon, Portugal. The castle dates from the 9th century and is located in the Sierra Sintra. The Palace of Sintra in the Vila of the same name is seen through a window in the Palace.

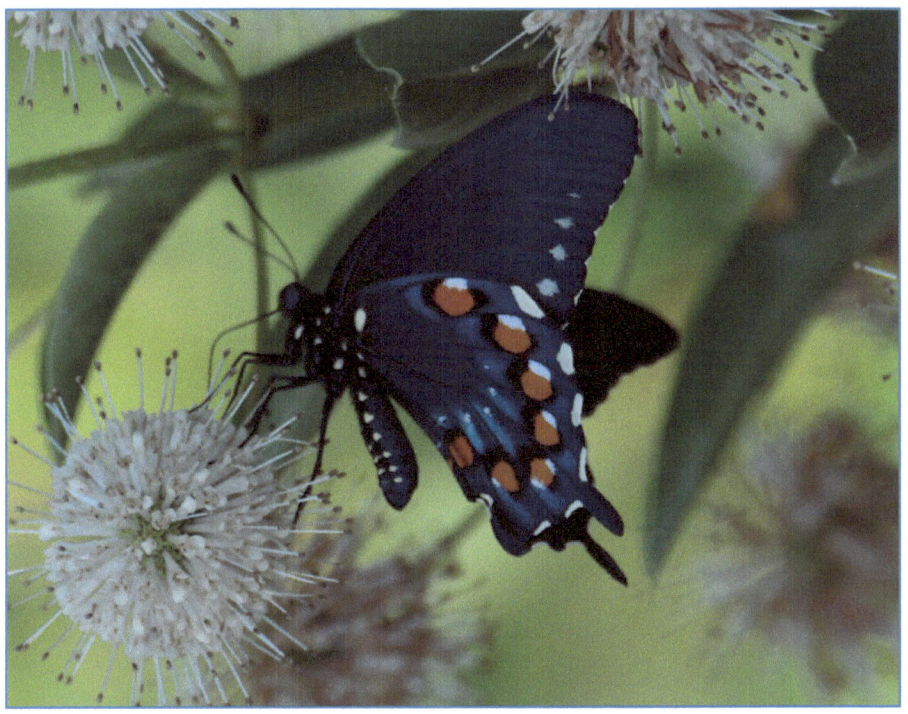

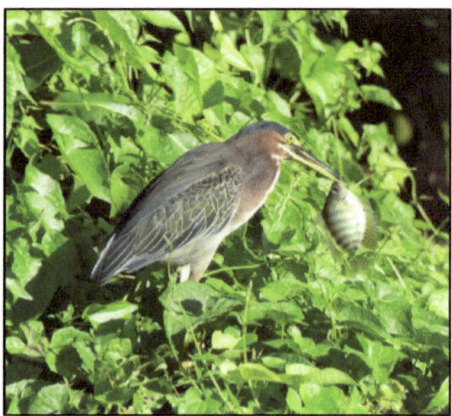

Gregory G. Dimijian, MD

Dr. Dimijian (1935–2017) was a psychiatrist and educator. He published numerous articles in BUMC Proceedings *on evolution, symbiosis, pathogens, parasites, and evolutionary issues in human conflict and sexuality. With his wife, Mary Beth, he published two books featuring his award-winning photography:* For the Love of Wild Places *and* Animal Watch: Behavior, Biology, and Beauty. *An interview of Dr. Dimijian was published in the journal in 2000.*

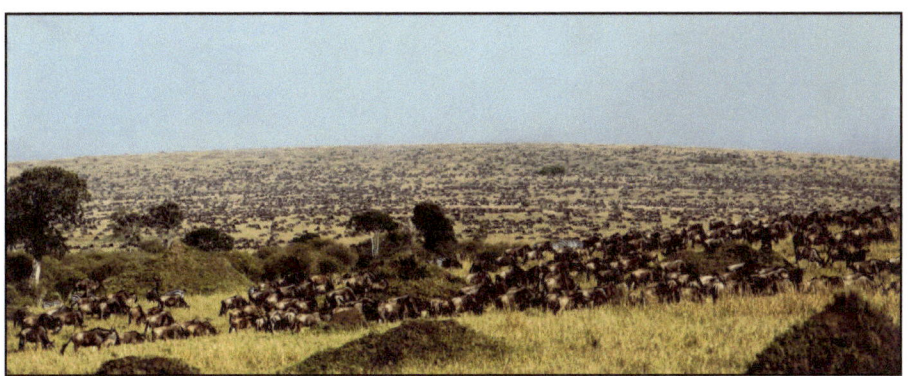

Wildebeest migrating in enormous numbers through the Mara Triangle of the Maasai Mara National Reserve in Kenya in September 2014. A small number of Burchell's zebras can be seen in the foreground. This is a pan merger of five separate photographs.

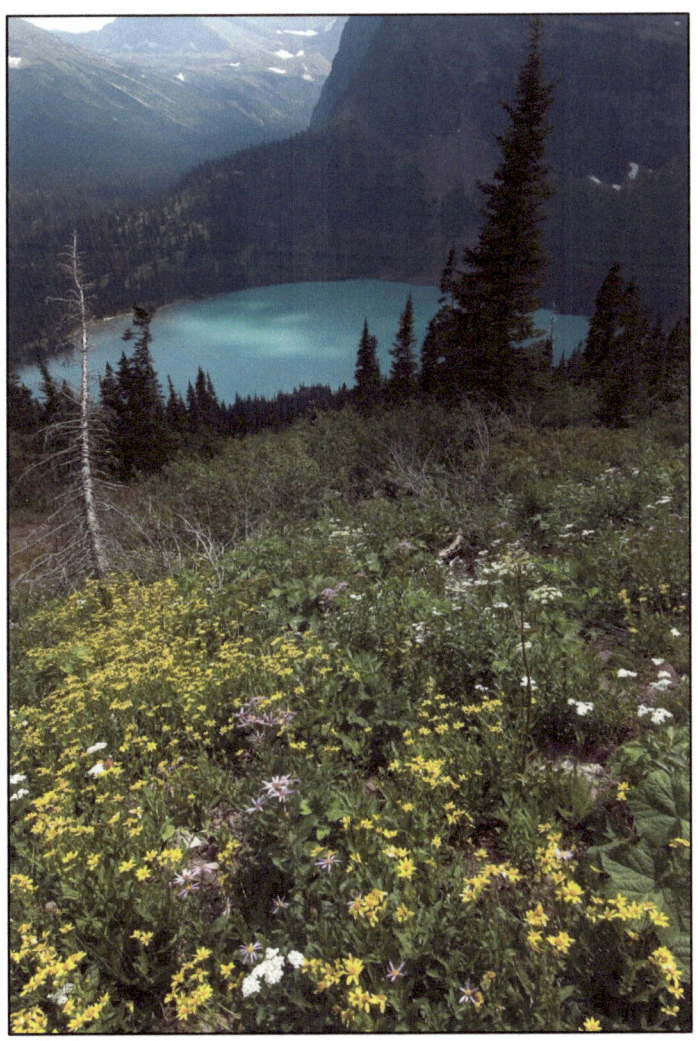

Arnica, aster, and yarrow adorn the slopes above Lower Grinnell Lake in Glacier National Park. Flower displays change from day to day over the 3-month summer season. The lake owes its blue-green color to "glacial milk," a suspension of finely powdered calcium carbonate scoured from limestone bedrock by the cliff glaciers providing meltwater to the lake. These cliff glaciers are rapidly melting back as climate warms.

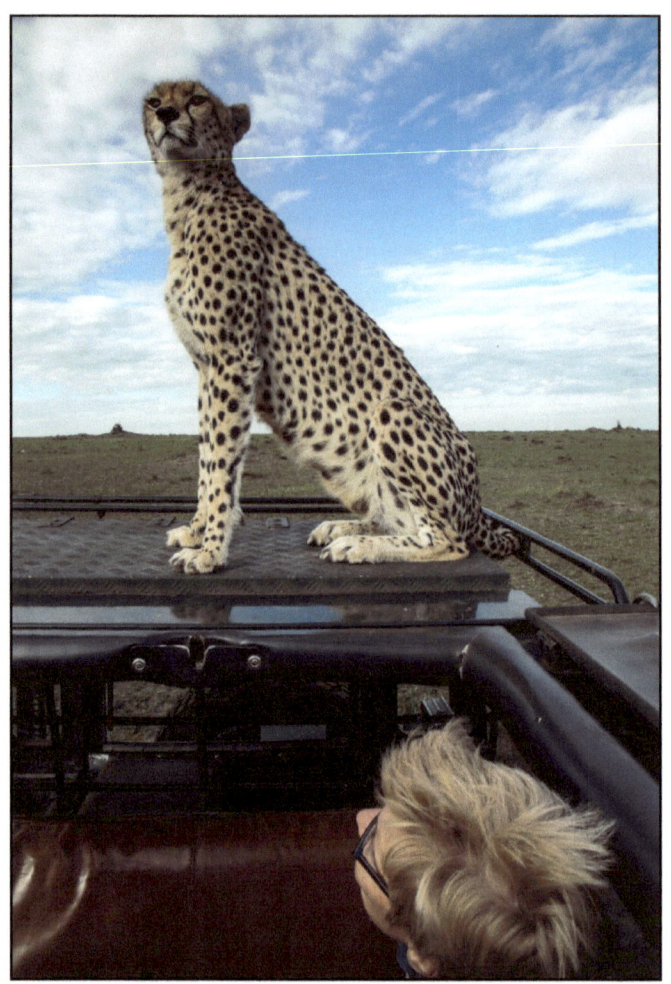

A female cheetah scans the plains from the top of our vehicle in the Maasai Mara National Reserve, Kenya, September 2014. Mary Beth Dimijian watches cautiously from her seat only a few feet away. With her five small cubs playing around the vehicle, the cheetah stayed on top for 45 minutes. This is a typical hunting strategy for cheetahs, which search for small gazelles on the open plains, instead of stalking in vegetation like lions and leopards.

Baron L. Hamman, MD

Dr. Baron Hamman was chief of cardiovascular surgery at Baylor University Medical Center from 2007 to 2014. He wrote this about his hobby: "I developed an interest in black and white photography in Ms. Brenda Watson's sixth-grade class, when we built simple cameras and shot pinhole photos. I have used 35-mm and large-format systems the past 25 years. These three photographs were shot during a trip to New Mexico in the late 1980s."

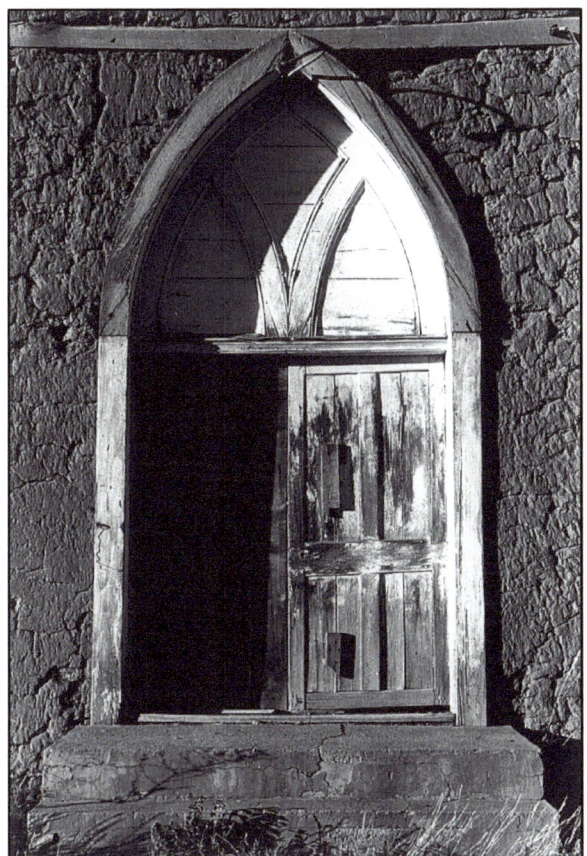

Doors.

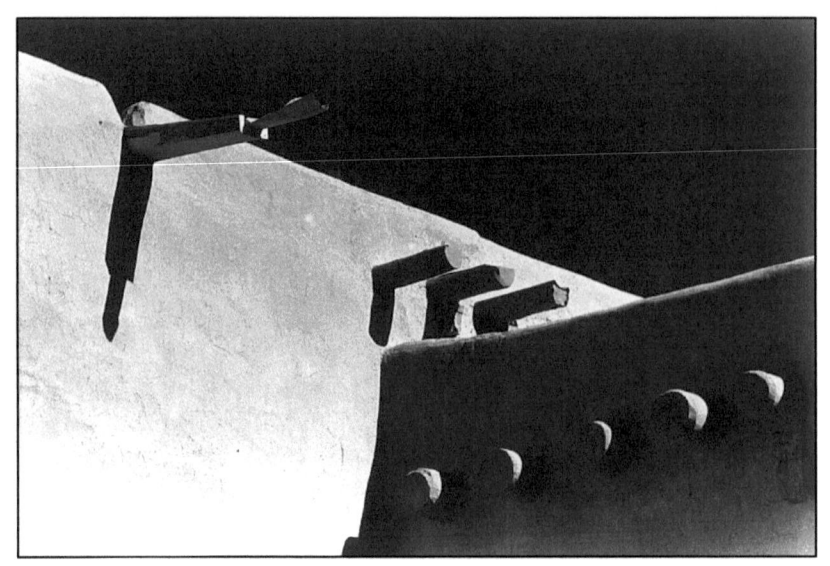

Adobe.

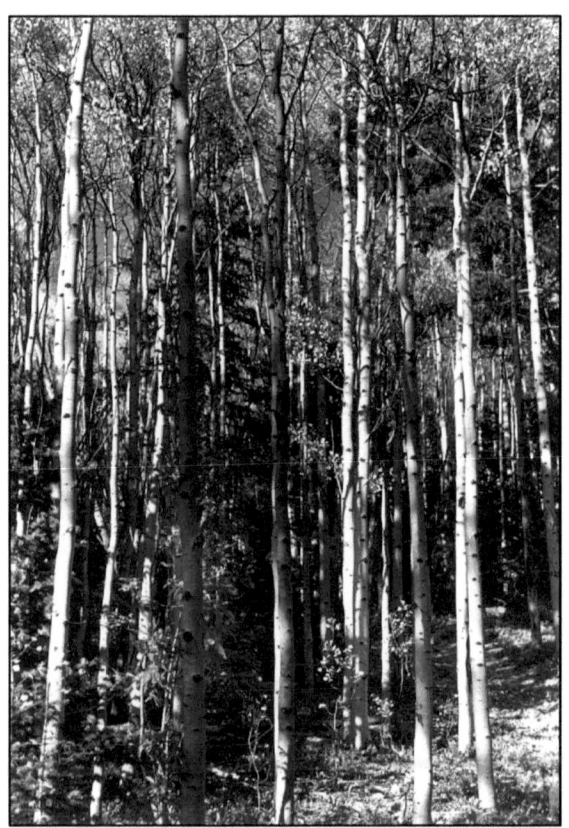

Birch.

Jay Hoppenstein, MD

Dr. Hoppenstein is a surgeon who was on the medical staff at Baylor University Medical Center at Dallas from 1971 until his retirement in 2005. He also served as chairman of the Department of Surgery at Presbyterian Hospital of Dallas.

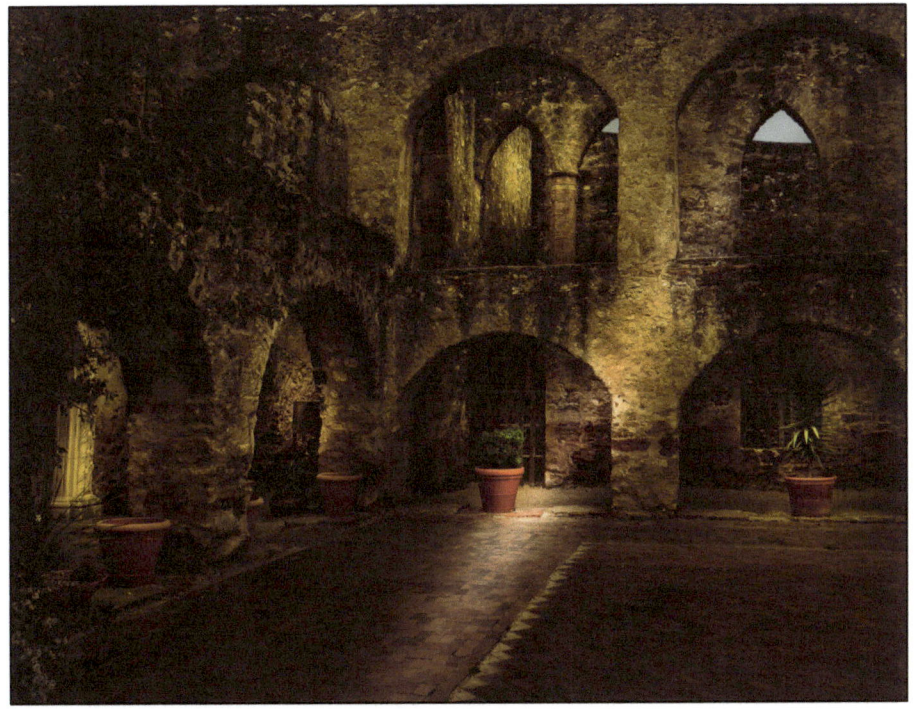

San Antonio.

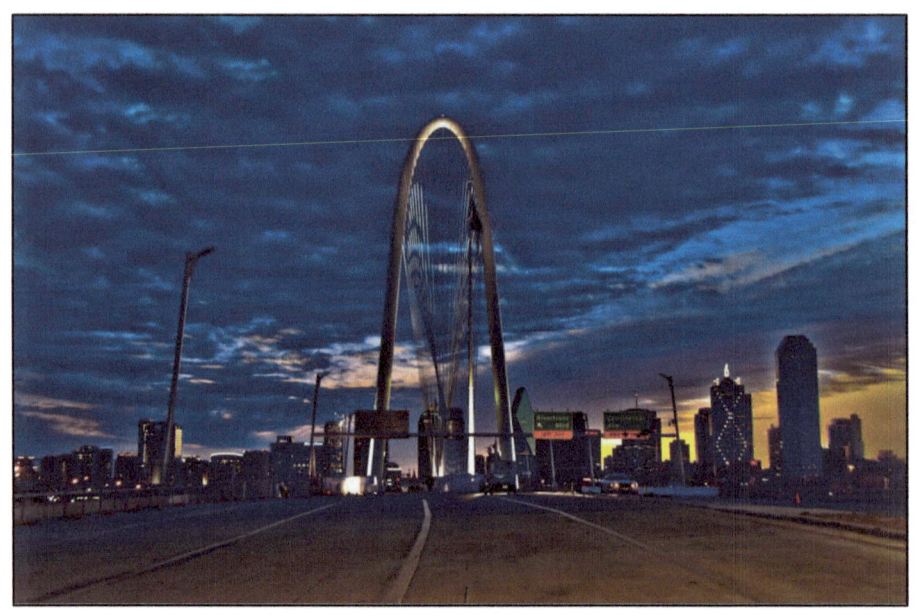

Sunrise over the Margaret Hunt Hill Bridge in Dallas.

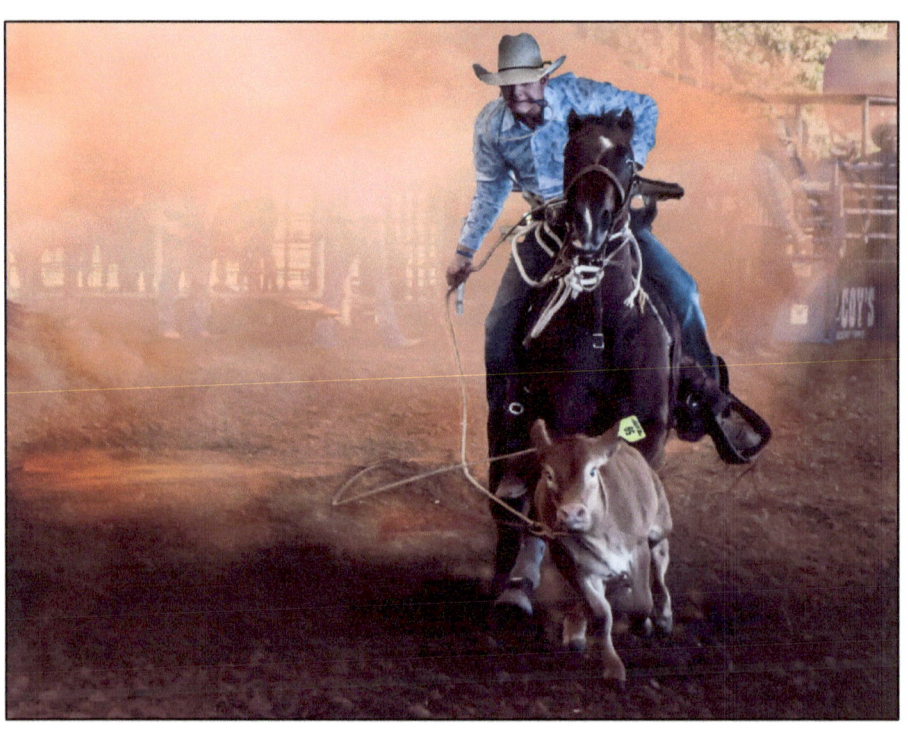

"Gotcha" at a high school rodeo.

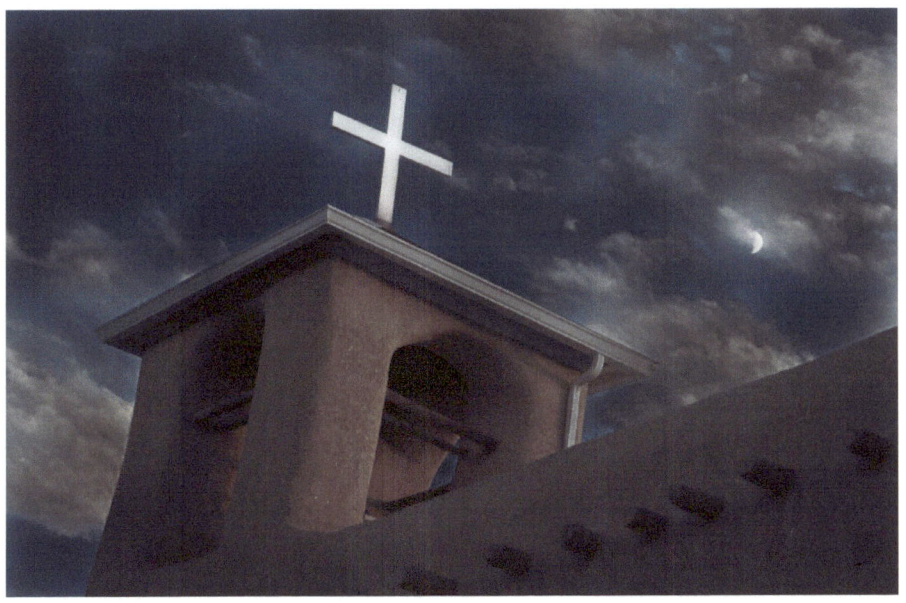

Medusa of the sea.

Vespers.

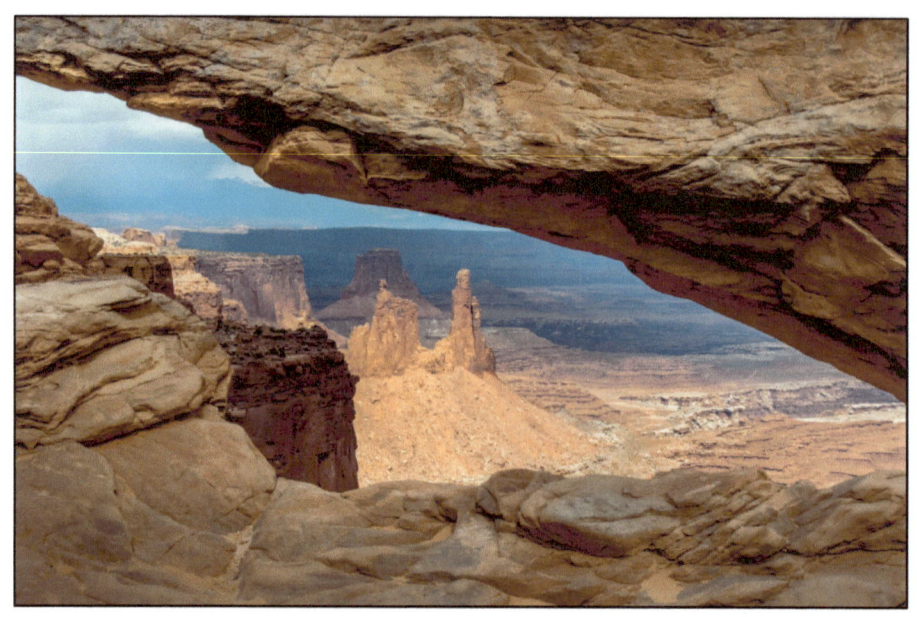

A storm across the mesa.

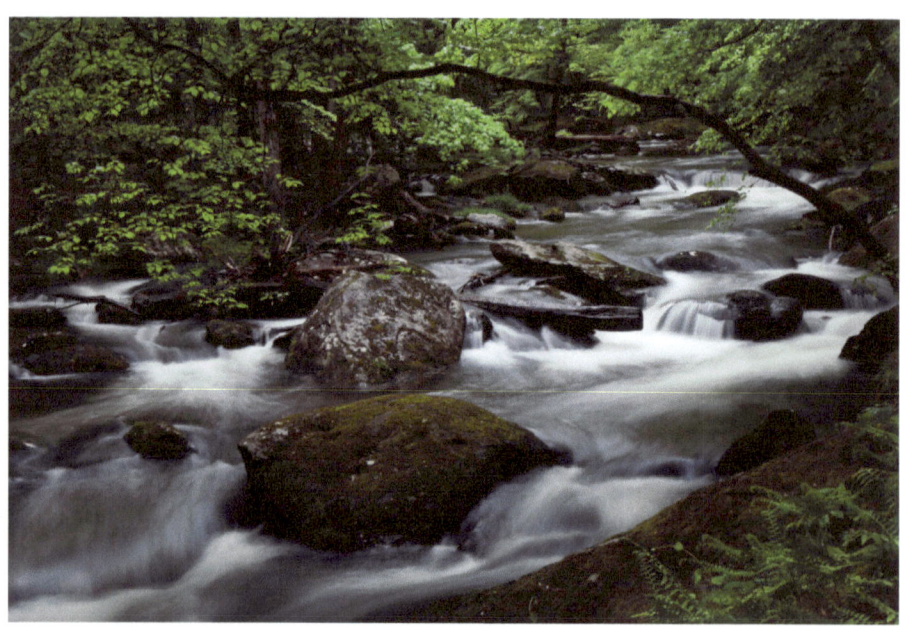

River.

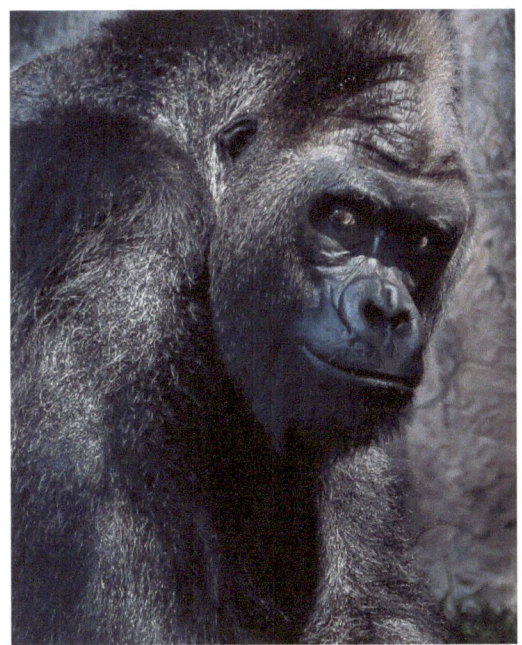

"Beguiling smile" at the Fort Worth Zoo.

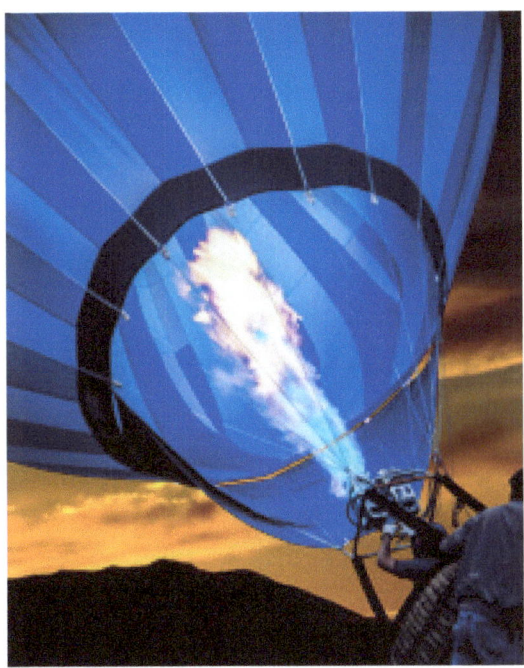

Rising at dawn in White Sands.

Amanullah Khan, MD, PhD

Dr. Khan is an oncologist on the medical staff of Baylor Medical Center at McKinney. He is an award-winning poet who has published poems in three languages and is past president of the Poetry Society of Texas.

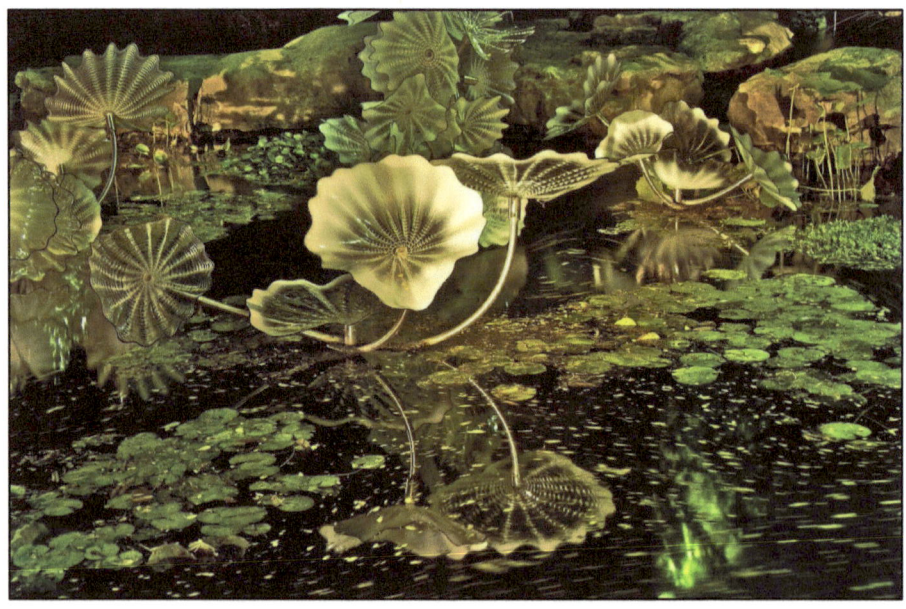

A Chihuly exhibit, Dallas Arboretum.

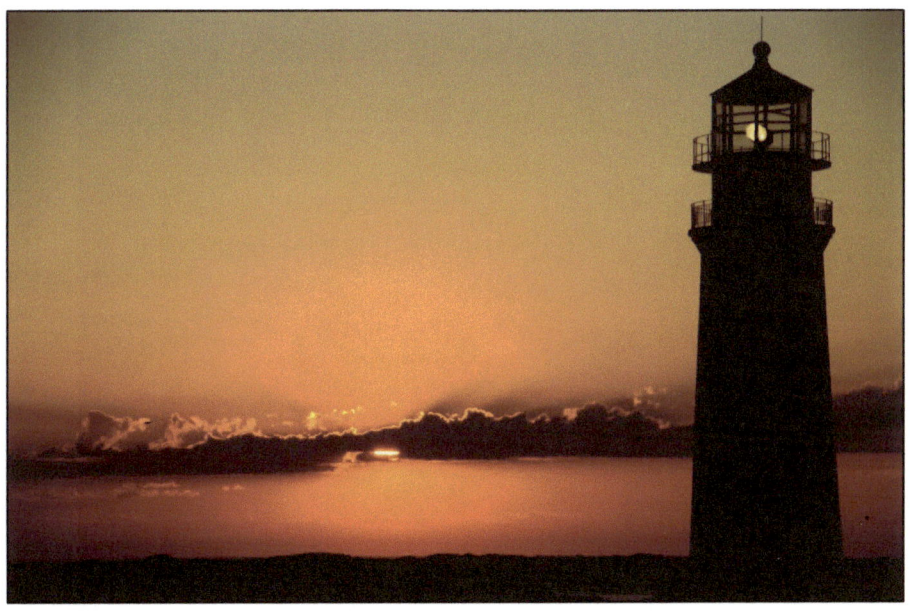
Lighthouse in Nantucket.

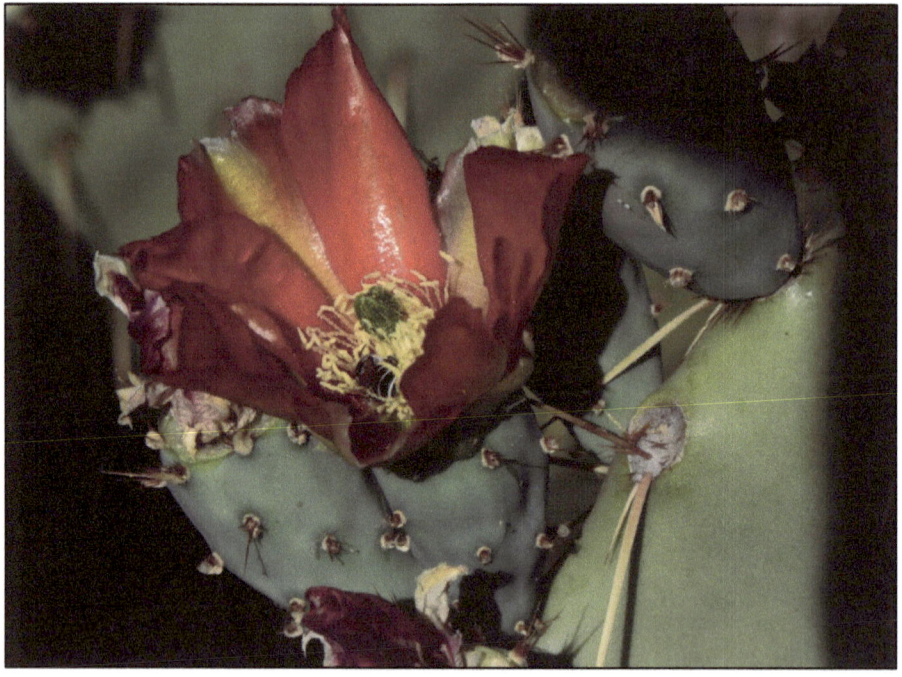

Desert beauty, a cactus flower.

A salute to first responders in North Texas during the pandemic.

Cancer

Preying on the unsuspecting
Exploiting genetic vagaries
Camouflaged insidious foe
Roosting in the helix
Perfidious mutant of the self
Pillages parent's nest

Laying primordial daughter cells
Spreading evil seed
Evading achromatic soldiers
Crosses sanguineous moats
Despised mother of all thieves
Steals innocent smiles

Trusting lives to my care
Daunting expectations
See the fugitive in their eyes
And I surmise
Can't pretend to be them
Yet they become part of me

Good Riddance 2020

Let's bid, apt farewell to Twenty-twenty
A blemish on the pages of history.
How shall we put it in the right terms, to
End it unceremoniously and

Remove all zits from the face of nation.
We may need a train with a trail of cars
To carry heavy load of injustice—
Which laid the foundation of recent movements.

We thank marvel of technology, that
Shined light on which could have gone unnoticed.
Streets got painted yellow but showed red stains.
These acts fail to feed mouths or provide jobs.

Covid took thousands of lives and left grief,
Man's insatiable want cast a green tent
But did not provide cover for off springs
Which left vulnerable children, naked.

Twenty-twenty saw an unparalleled
Civic turmoil which tore nation apart
People are waiting for a deluge of
Divine intervention of healing balm.

Perception

He had seen a falling robin in the blooming pansies.
Compelled by an inner urge rushed to his aid.
Flaccid bird was now nestled in the doctor's palm.
Fetched water from the fountain;
Moistened bird's beak.
Reflexive movement of the tongue gave a flicker of hope.

Accustomed to dispensing care. The fingers were in action—
Massaging chest of the bird, helping him to breathe.
All the while lips whispered gentle comforting sounds.
Suddenly the bird moved,
Raised the head and shook stupor off.
Flew past the hypnotic berries he had eaten earlier.

People in the crowded office stood on their feet,
Watching the entire scene through the glass window.
Someone boasted with glee: "That is my doctor."
Lobby full of waiting patients clapped in approval!

Poet

I am a carpenter and an artist.
I chisel words to frame the ideal.
To render the engaging piece of verse,
I spin them on the spinning wheel of mind.

Mold words with the nib of a tactile pen
And level them to fleece the thorny spots.
But I leave enough surface for others
If they desire to espy their own craft.

CABG

The nurse flaunted full privilege of her license
And tasered light into my face
While sun was still stretching under the covers
And my mind flirted
With the daughter of the poppy
Dancing in my veins.

"It's time for a walk," she declared.
It was less than 12 hours since the bypass.
"It's too early," I muttered, shaking the cobwebs.
"Doctor's orders." And she started gathering
Host of wires and the tubes,
Annexed to my limbs and organs.

Propped up, I briefly stood
And promptly slumped to the floor.
The room turned a hybrid maze:
A Ferris wheel and a merry-go-round.
Tests revealed: machine and sponges had
Siphoned off half my blood.

And my intolerance of the drug
Had my brain on a trampoline, but I felt no pain.
For two days I watched the room from the ceiling.
People came to shower wishes,
I have vague recollection.
If this is, they call high, I prefer the low.

Sleepless

In the dark and quiet still,
Deep in mind, a nagging, stirs.
A constant drip, drop by drop:
Ripples play, hula-hoop,
In the ocean of recall.

As if this is not enough,
Pings of drops penetrate,
Sending deep prodding charges,
Tripping cells, from cell to cell.
A dissident storm pervades the grid.

In this upheaval of the mind,
Distant pledges and resolves,
Pronounced in the faded years,
Rise against incarceration
Tearing down the walls.

Remind of oath: "I shall . . . consecrate my life
To the service of humanity."
And summon escapee conscience to the
Pen of misery:
Grimacing human figures.

Life's quality measured in cups,
The cup needing pills,
Empty for the want of means.
Reprieve from the physical ills,
Competing with the famished den.

A distant voice asks the wind:
"Where stands the opulent village,
Promised to these weary bones?
Is it branded as utopian?
So the village remains imagined."

Hermits in the Open

Hydraulics multiply
While muscles atrophy.
Through the evolution-scope
See the wasted limbs!

Creeping concrete around the globe
At a dizzying pace.
Creatures moving fast and furious
Up and down the terrain.

Suffocating, burning fossil,
Visible air to breath
Suspended sewers above the tarmac
Rise higher and higher.

Menacing soot defaces sun,
Vital rays are under siege.
Confused are the sunflowers
Wondering where to look.

Shadows used to embrace strangers
In the golden rays—
Masked faces, lost embraces,
Hermits in the open.

Mount Rainier

 I
Loosed of the digital collar
and the wireless leash,
strolled on a vibrant carpet
laid by the fallen leaves.
Yellow, gold, shades of red,
sprayed on the sloping canvas.
Mixture of the fertile lava
and plethora of decay
furnished elements for the paint.
Summer having bid adieu,
approaching winter nudged the sun
on a southerly course.
A shared kingdom of serenity,
everyone was welcome.
Each whiff of mountain air
cleansed my defiled lungs,
choked by the inhaled soot
in the urban labyrinth;
healing my cyanotic soul.

Longevity

A bushel of plums was on the table.
Soft skin tightly stretched,
Fresh and tangy, mouth watering,
Shiny youthful glow.

A few were eaten every day.
Some were left behind.
Fewer and fewer were in the basket
Each passing day.

Although ripe and sweet with time
Plums were losing sheen.
Notable was the loss in shape.
The silky skin was rough.

Last remaining was so wrinkled,
What a change with time.
Longevity is a cruel bargain.
Plum is bartered for a prune.

It is Never Easy

White coat became a vise.
She was younger than my daughters.
I was replaying the taxing moment.
How to say: "You have leukemia."

To bar static, I had spun a cocoon
while streetlights whizzed by.
Unsnarled cobwebs woven by her stares
as I rewound the hospital scene.

Reflecting how I walked the tight rope:
I had lumbered to her room,
balancing art against science,
afraid to utter ill-fitting words.

Room was a cave of darkness.
Beams of concern and inquiry
crisscrossed thickness of the air.
I could have clawed under the layers.

Her vagrant eyes combed the desert.
I paused, devising ways to connect:
hands tucked in my pockets,
inessential stethoscope choking my neck.

Chards of dismay in the mouth,
I proceeded to assure: "I have led this trail before—
across the cliffs and canyons
lies the valley of conquerors."

"I can read your face," she announced.
"We can fight it." She drummed out her grief,
offering me a rose of solace
while her finger pads bled.

Neurology of a Poem

During lapsed conscious hours, I have often
wondered and received mutable counsel
in varied tongues—at times uninvited.
This time it was a virtual dream.

I sensed caress of a woolly presence
While the pen was stitching strewn patches of
similes, metaphors, rhythm and rhyme.
"I am watching you from a vantage point.

"Your skull offers no barrier."
He went on: "As I watch the marauding
stampede of lines on the slopes of your mind,
I see that you are trying to create.

"Innovation is not forethought or a whim.
It hails down from sky.
Gains access through the cranium and
hacked mind slips into reverie.

"Chatter in corpus callosum rises,
untapped cerebral sectors are recruited—
some transmitters are kept at bay. Mind hoes
what is known and jumps terrestrial fences.

"Prefrontal shackles are banished.
Societal reins are left dangling.
No more sentries! No more walls! No checkpoints!
Silence zone is in effect for the critic's megaphone.

"Unleashed limbic flow is nourished
by the Gamma spike in brain.
There! You pirouette with the lines
and feel the Aha moment."

Devotion

Hell emptied its belly,
dropped lava from the sky,
where once stood a compound
in a remote village.

Then there were only ruins.
Barking and sniffing rubble for familiar scents;
he emerged limping
from the dense cloud of dust.

Something in there, he sensed,
in that strange mixture of smells,
which bound him to the scene.
He would not break the shackles.

Minutes turned into hours, hours into days.
His friend and his master
wasn't there to fill the bowl.
Small puddle, next to house also went dry.

Hunger pains slowed him down,
but he sniffed and he dug,
till his paws had no pads and his
bark waned to whimper.

Had no strength to prop his head.
Ears hung flaccid.
Curled up in the rubble,
head resting between legs.

Panting ceased, breathing slowed—then stopped.
But the eyes remained open, waiting for his master.

Confounding Images

there lies a broken
human form

and I scramble
to buttress

crumbling ruins of a marvel
of all marvels

now spent
and abandoned to my ward

needing replacement
body parts

while television
on the wall

pans aftermath
of a smoldering battlefield

littered with
severed callow body pieces

Unusable!

Terry C. Lairmore, MD

Dr. Lairmore is director of surgical oncology at Baylor Scott & White Medical Center – Temple.

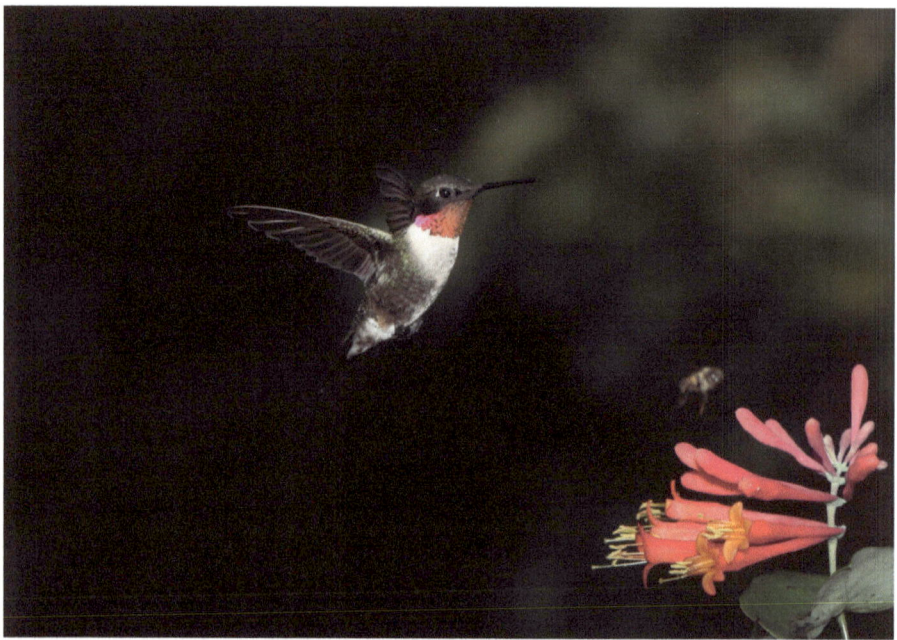

Ruby-throated hummingbird with bee at Trumpet Honeysuckle, taken at Stillhouse Hollow Lake, Belton, Texas.

John L. Manning, MD

Dr. Manning is program director of the family medicine residency at Baylor Scott & White Medical Center – Temple.

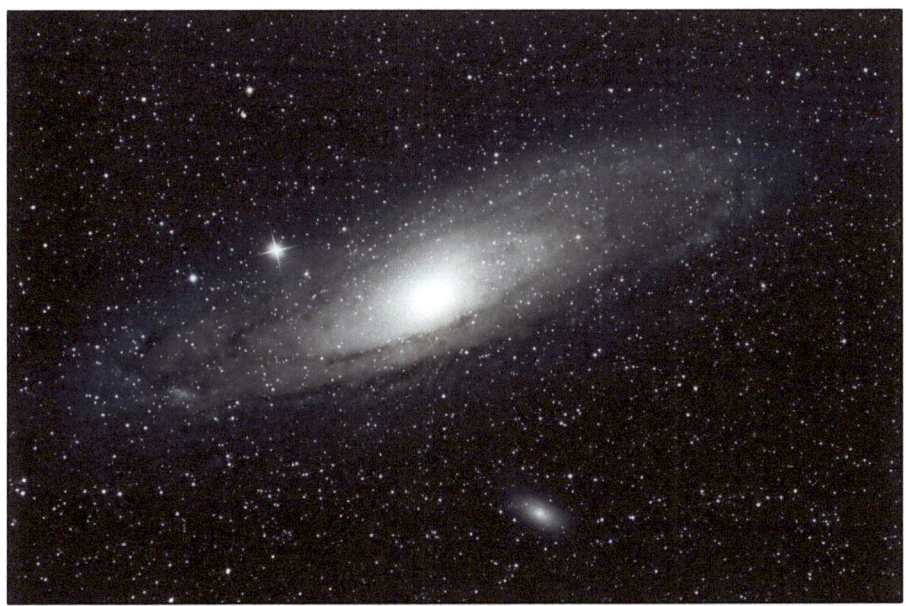

A photograph of the Andromeda Galaxy, taken with an Orion 80 mm refractor telescope from Troy, Texas. The closest spiral galaxy to the Milky Way, Andromedia is 2½ million light years away—so the photo reflects the appearance of the galaxy 2½ million years ago.

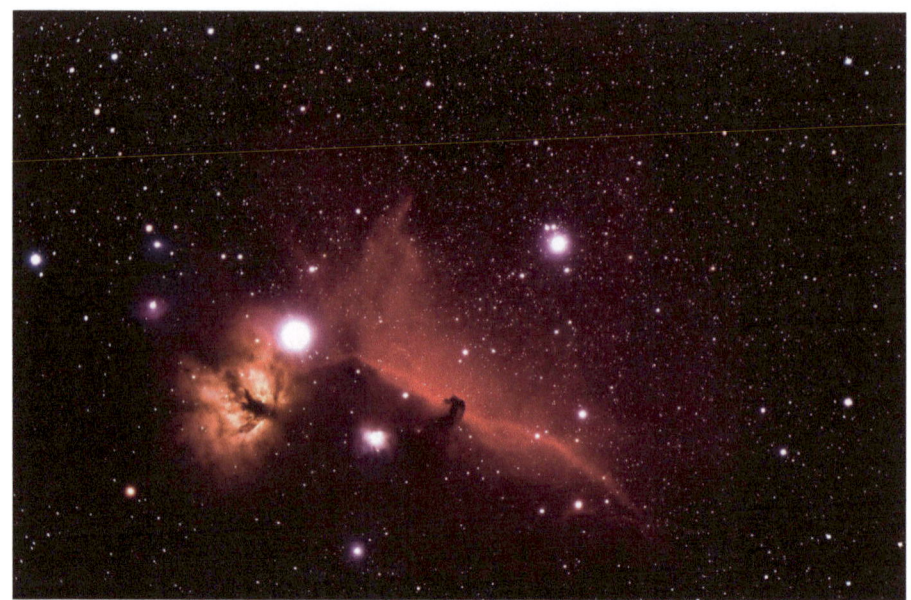

A photograph of the Horsehead Nebula, taken with an Orion 80 mm refractor telescope from Troy, Texas. This nebula is a collection of mostly hydrogen gas located next to the most rightward star in the belt of the constellation Orion.

Jeffrey Michel, MD

Dr. Michel is vice president of cardiovascular services, Central Texas, Baylor Scott & White Health, and chief of the Division of Cardiology at Baylor Scott & White Medical Center – Temple.

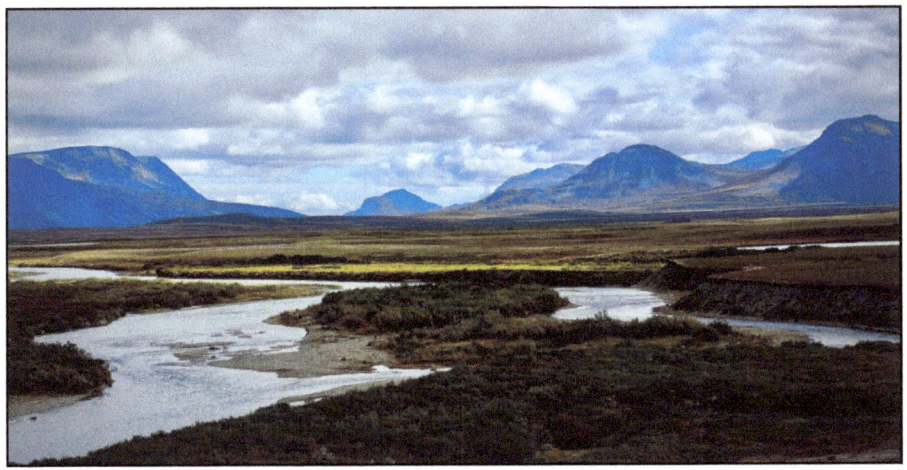

Katmai National Park, Alaska.

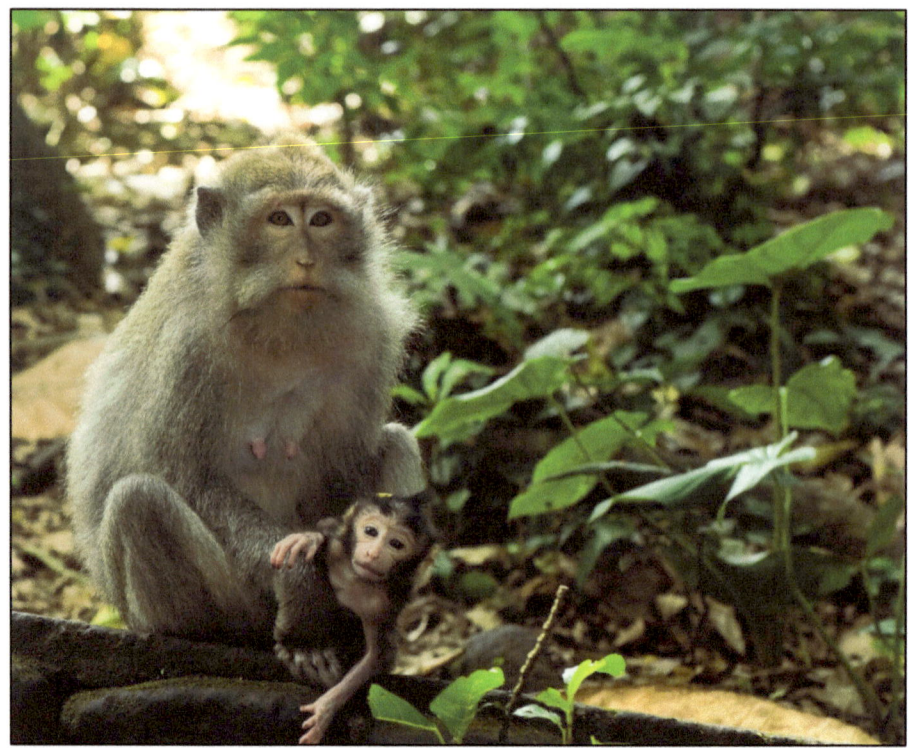
Mother and child: Balinese long tailed monkeys (*Macaca fascicularis*), Ubud Monkey Forest, Bali.

William L. Rayburn, MD

Dr. Rayburn is an obstetrician/gynecologist and chief medical officer of the College Station Region for Baylor Scott & White Health. He serves as a trustee for Baylor Scott & White Holdings.

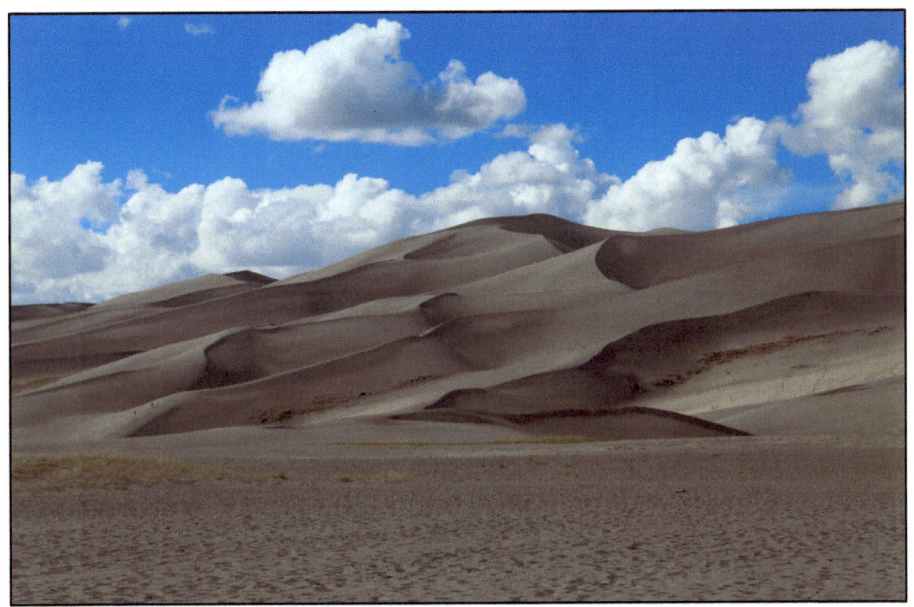

Great Sand Dunes National Park outside Alamosa, Colorado.

Super worm moon over the San Juans, February 2020.

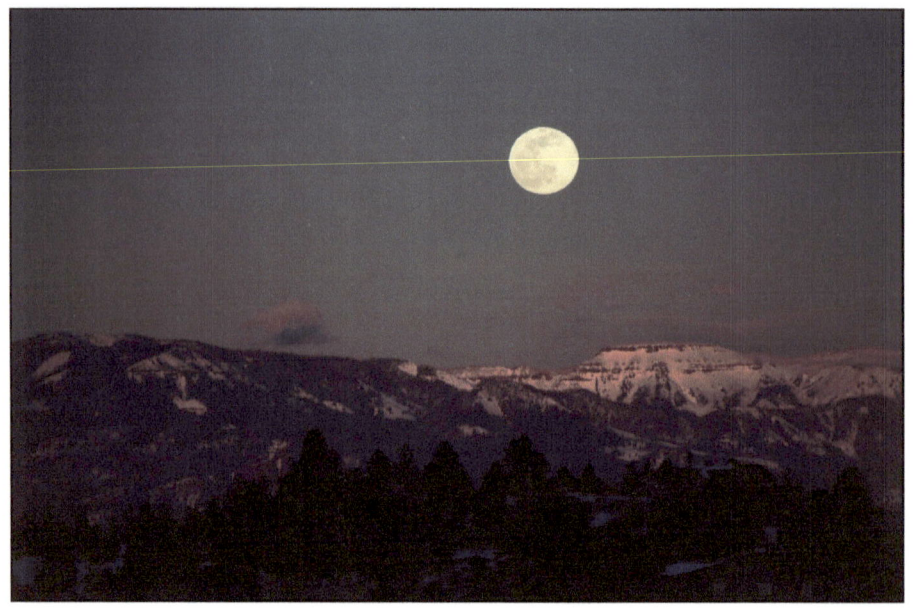

Brazos County bobcat.

Maruf A. Razzuk, MD

Dr. Razzuk served as associate clinical professor of thoracic and cardiovascular surgery at UT Southwestern and on the staff of Baylor University Medical Center until his death in 2000. He wrote this about his paintings: "Growing up in a village abroad with open countryside and an abundance of colorful flowers all year round, I came to appreciate nature's beauty, which influenced my heart and soul. In the early years of my painting hobby, I expressed my love of colors through scenes of nature and my surroundings. My focus has changed recently, with painting becoming a medium to express my gratitude to God, friends, and the values that gave me the determination to overcome difficulties and achieve my childhood dreams."

"This painting shows where I grew up and learned that a simple home and living can give one the strength and determination to achieve one's dreams."

"This painting shows a friend who saved my family from tragedy many years ago."

Jed Rosenthal, MD

Dr. Rosenthal is a cardiologist in Dallas, Texas.

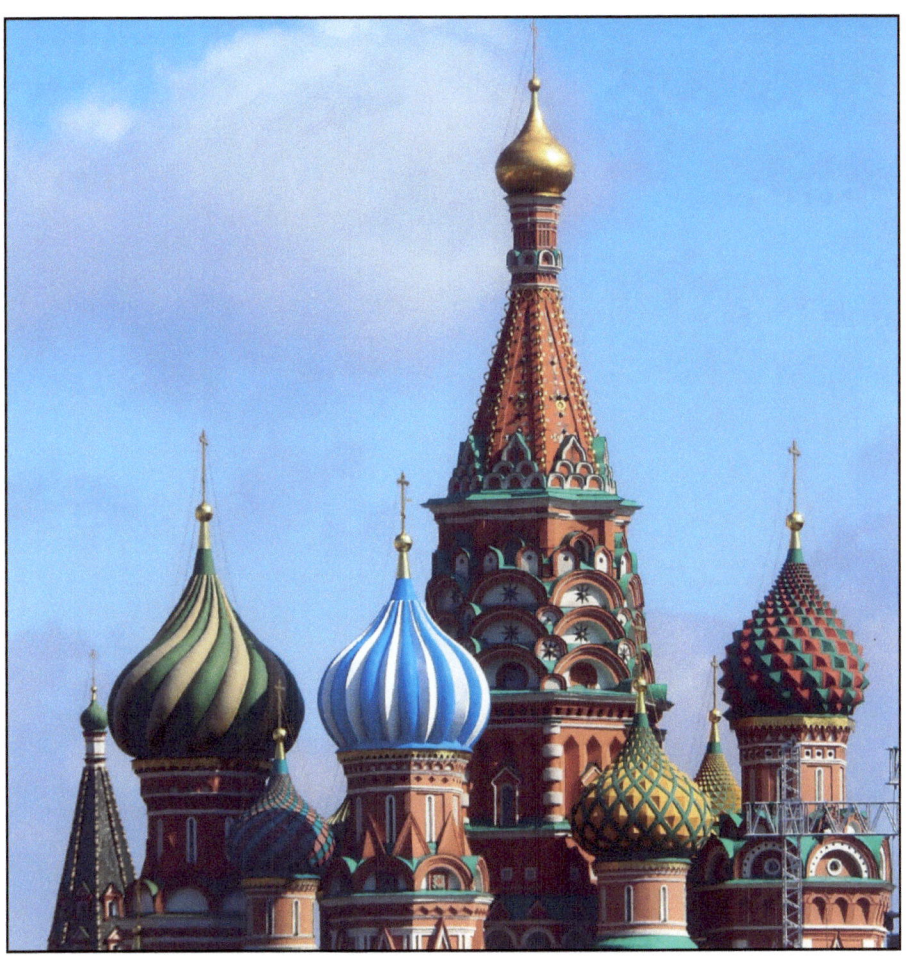

St. Basil's Cathedral in Moscow.

The Margaret Hunt Hill Bridge in Dallas.

Victoria Falls.

Rocamadour, France.

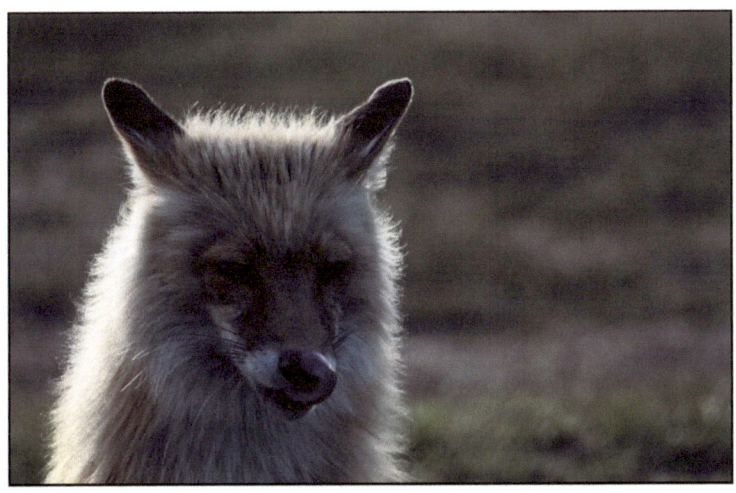

A red fox from Alaska.

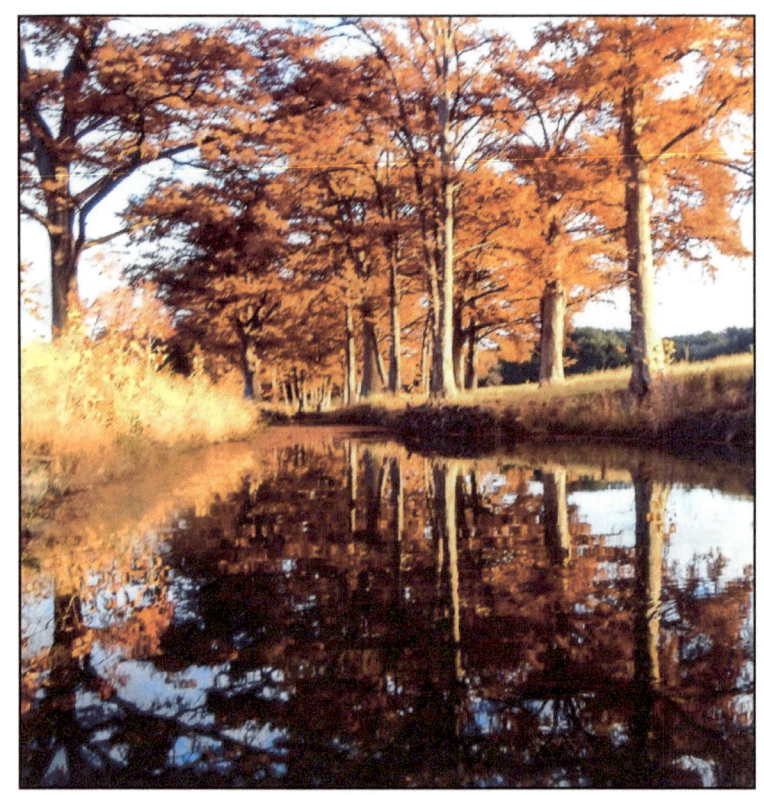

Joshua Creek, Texas Hill Country.

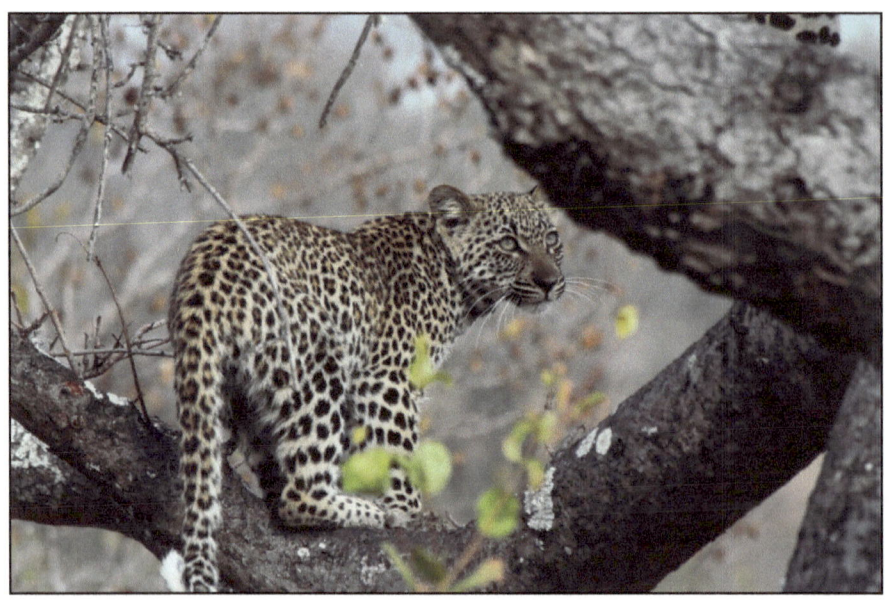

A young leopard in South Africa.

A cheetah and her cub in Tanzania.

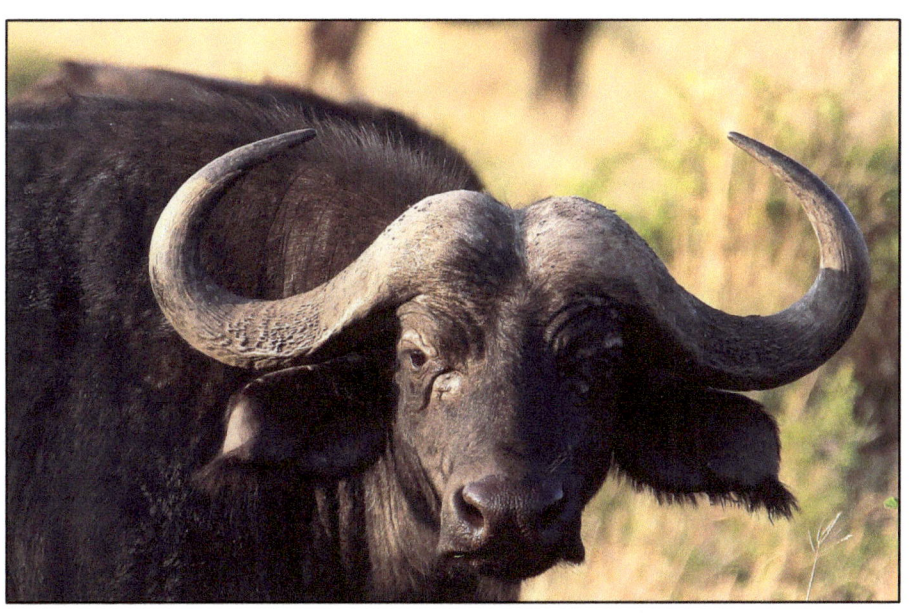

Cape buffalo.

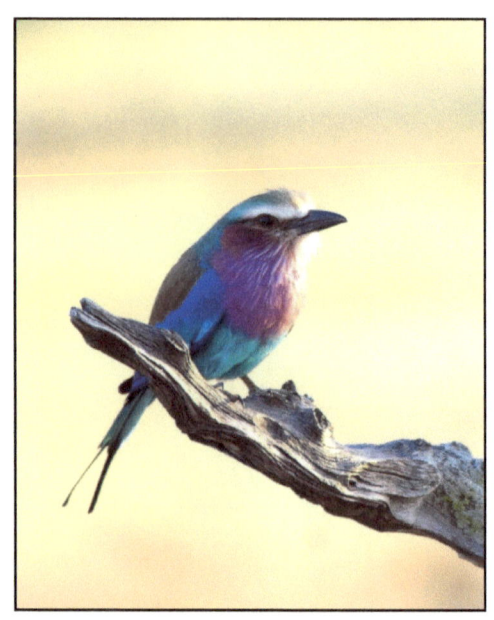

A lilac breasted roller from Botswana.

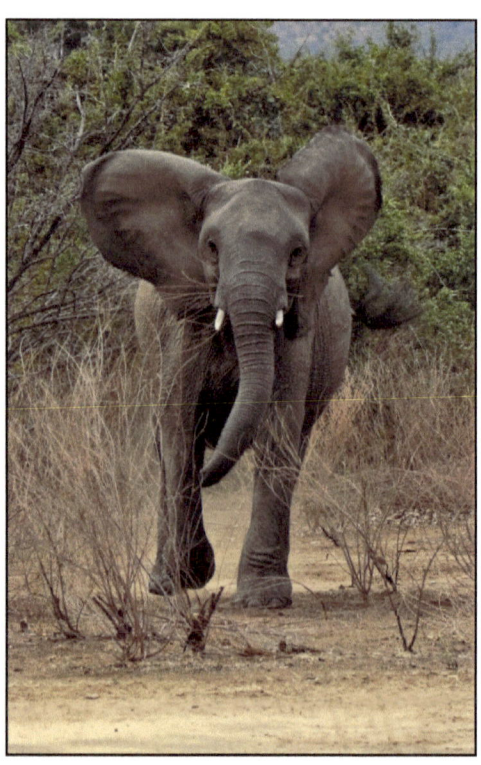

A charging elephant in Zimbabwe.

Rolando M. Solis, MD

Dr. Solis is co-medical director of the cardiopulmonary rehabilitation program at Baylor Scott & White The Heart Hospital – Plano, Plano, Texas. He described his photography hobby this way in 2009:

> I believe I inherited my love for visual art from my late mother, who was good in drawing and ceramics. I started photography as a hobby, mostly photographing family, especially our growing children. Later, I discovered the beauty of nature photography, with initial emphasis on flowers and, later on, landscapes and then living creatures. Birds, animals, and insects are some of my favorite subjects.
>
> Vibrant colors and intricate figures attract me, and when I delved into macrophotography, I discovered a totally new world. It is hard to believe the existence of beautiful and striking structures the naked eye or the ordinary photo image could ever perceive!
>
> Photography has not only opened my eyes to the beauty of nature surrounding us but has also encouraged me to commune with the great outdoors. At first, this was just an outlet to ease boredom, but I later found that it also provided me exercises in disciplines that I have been able to apply to my profession as an interventional cardiologist, where I have to be patient, precise in judgment, and speedy in visual and manual adroitness. I spend most of my time photographing my subjects at the Fort Worth and Dallas Zoos, the Dallas Arboretum and Fort Worth Botanical Garden, our backyard, and also in a portable makeshift studio in our kitchen for some of my macro shots. The hobby has been relaxing and rewarding, especially every time I win an award at the Dallas Camera Club, where I am a Master Member.

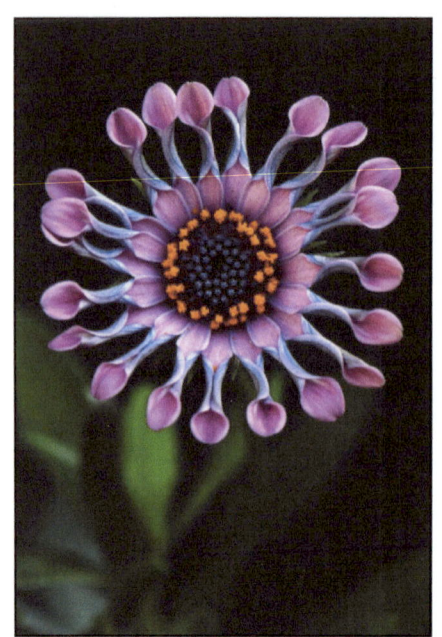
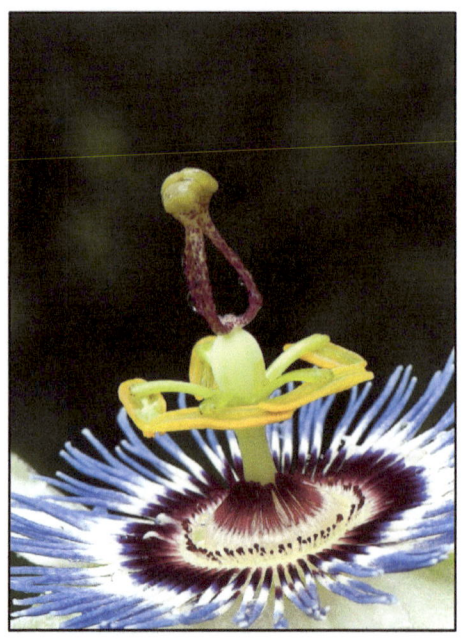
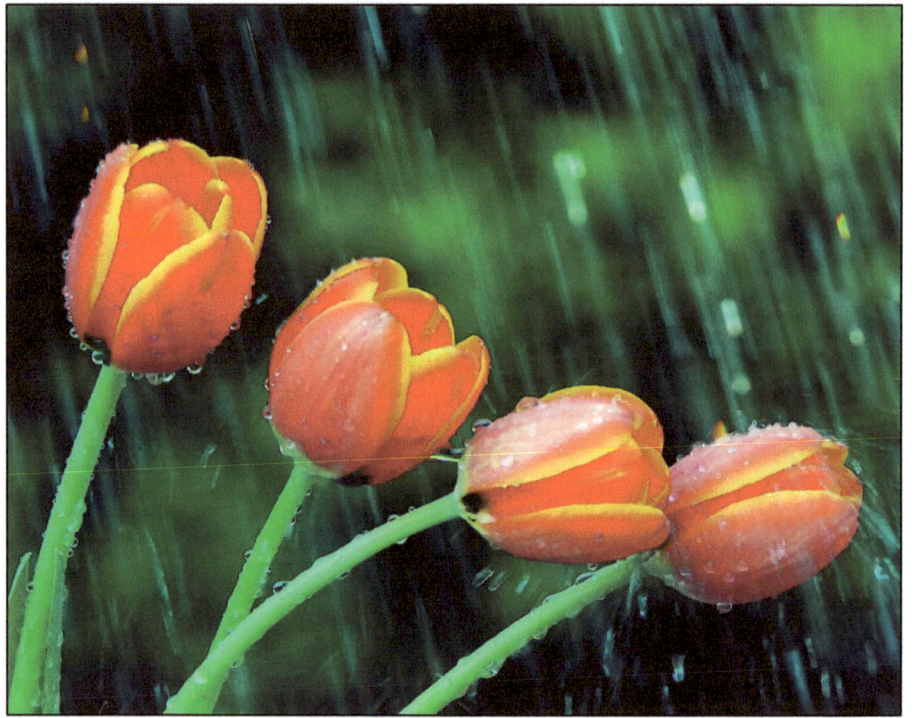

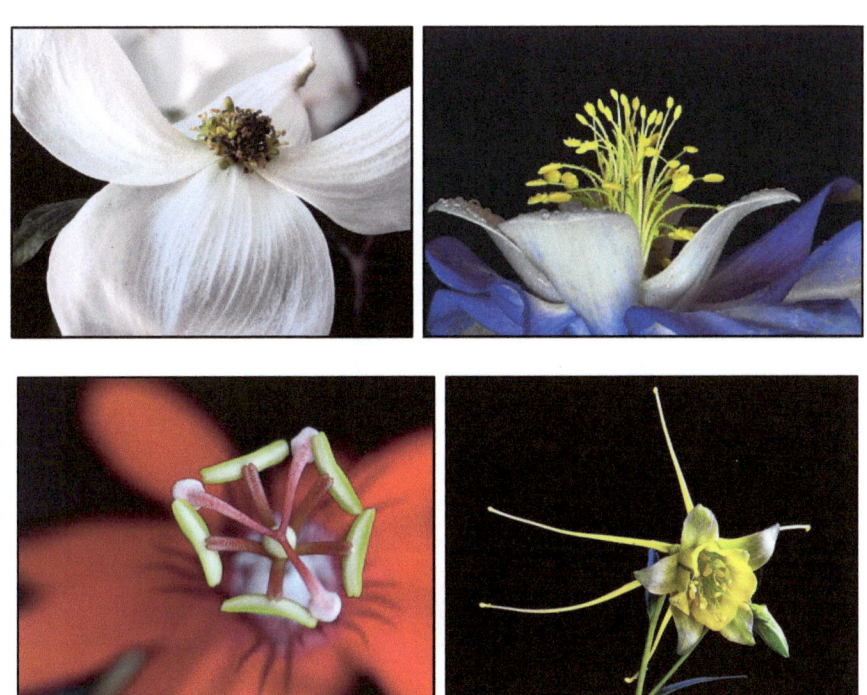

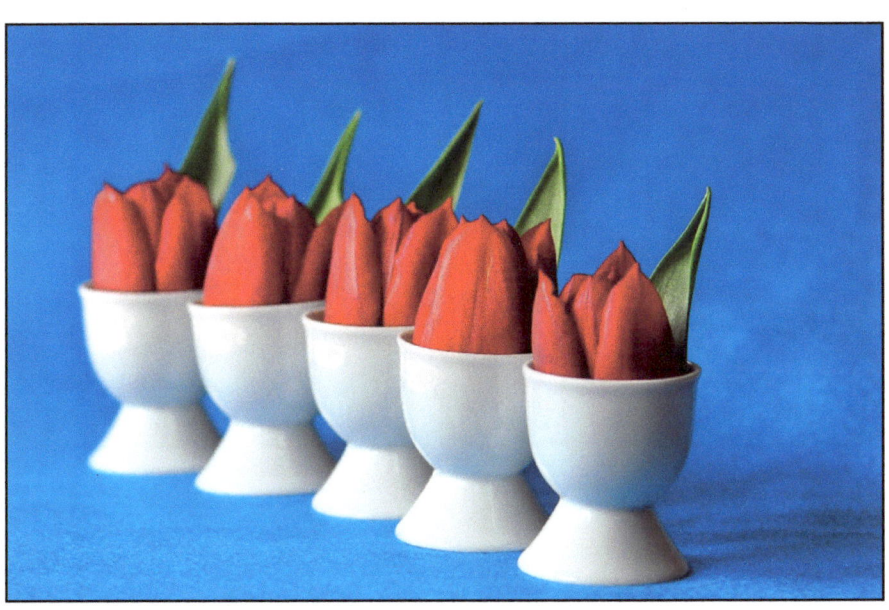

Red tulips.

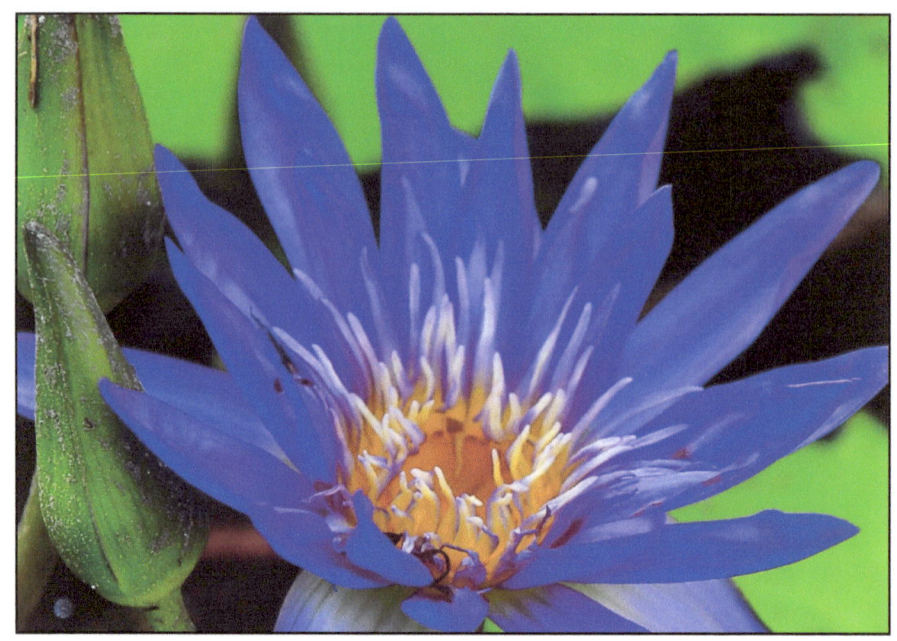

Water lily.

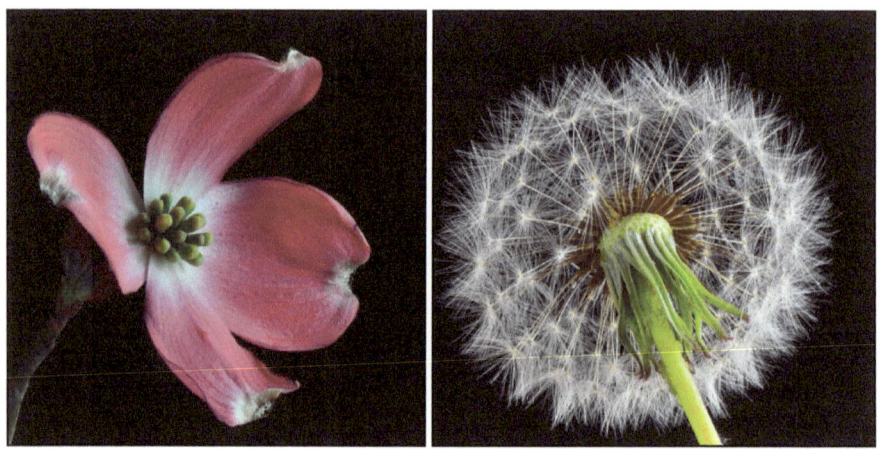

Spring flowers.

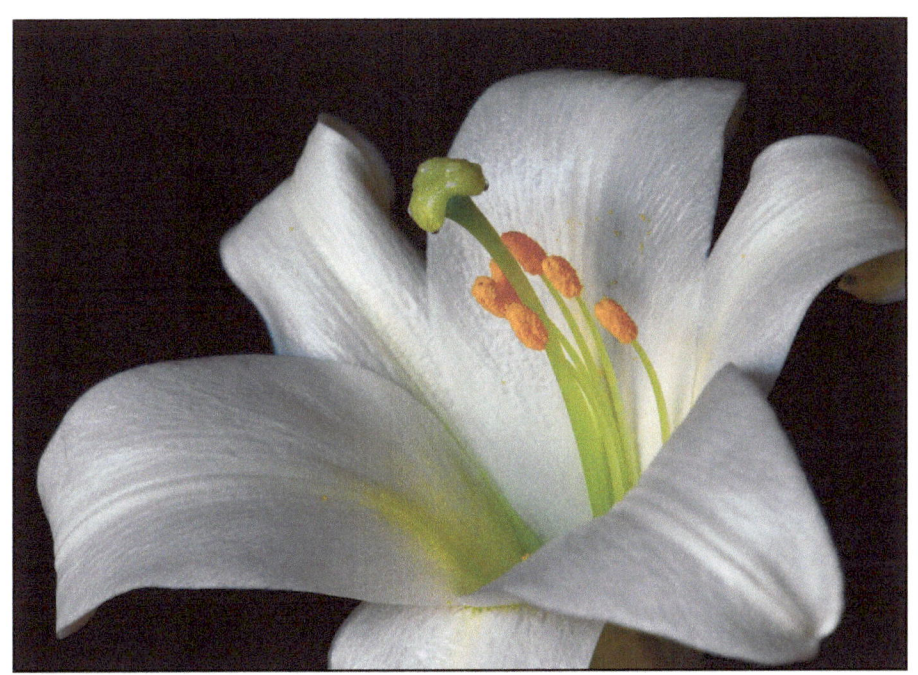

Easter lily.

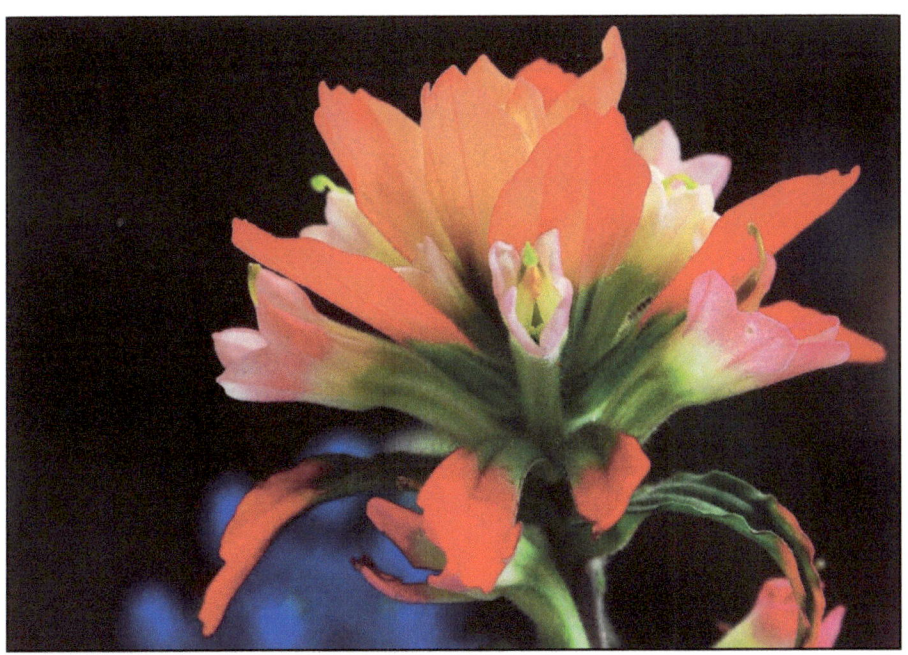

Indian Paintbrush blossom.

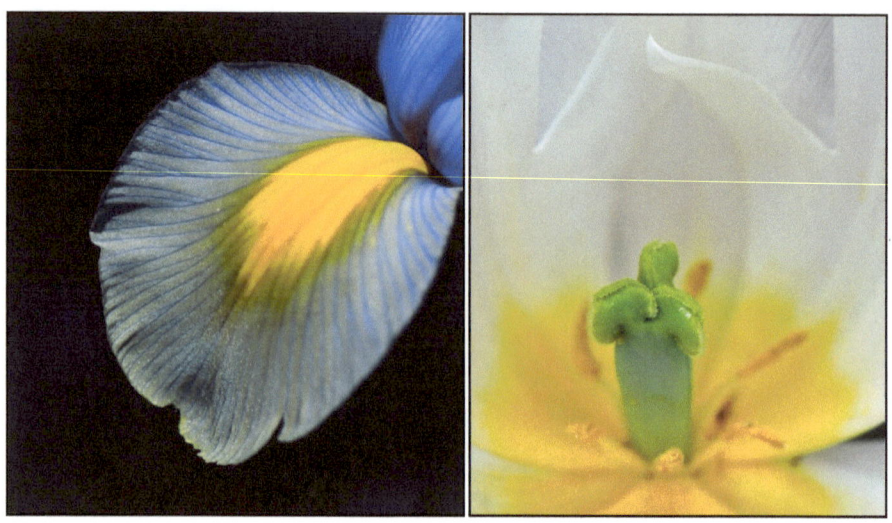

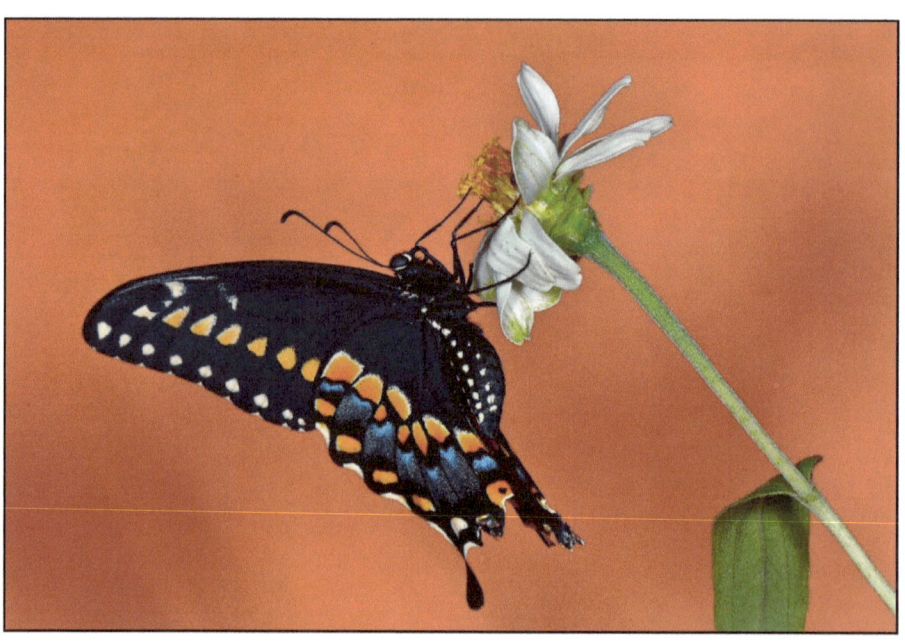

Black Swallowtail Butterfly.

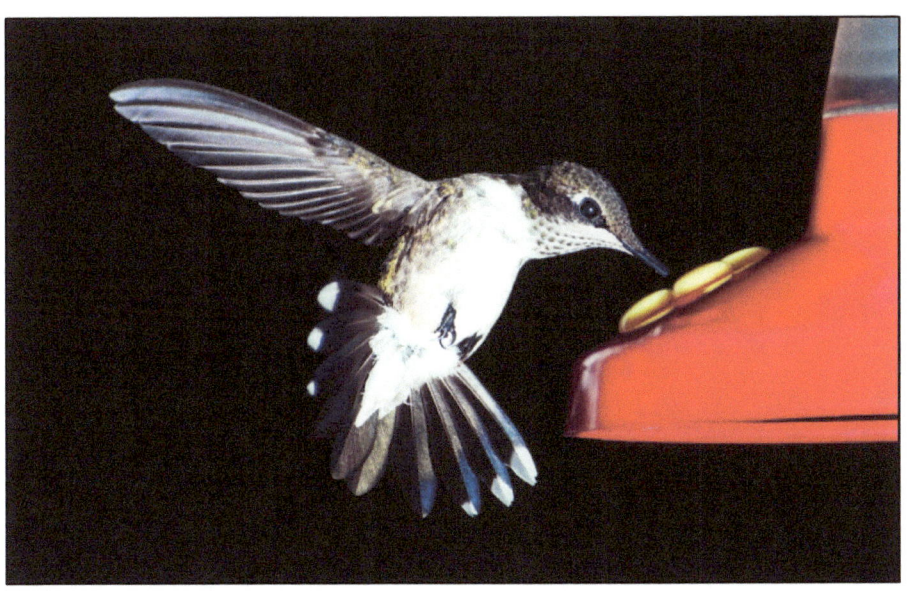

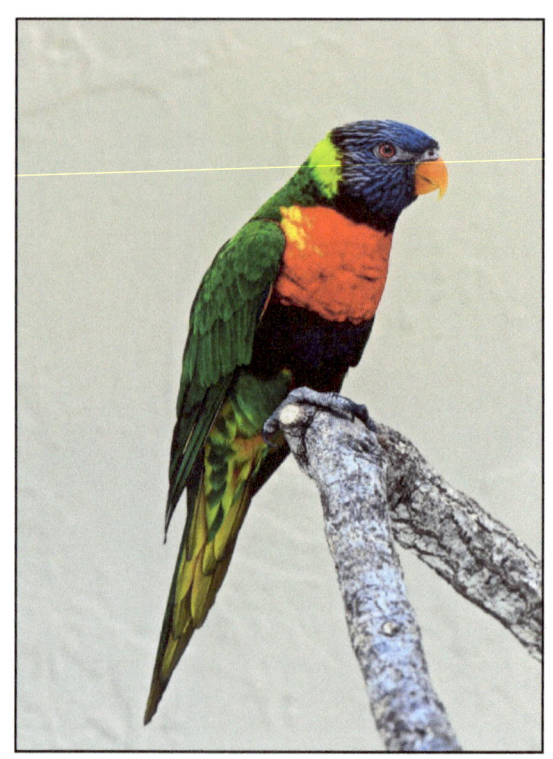

Parrot.

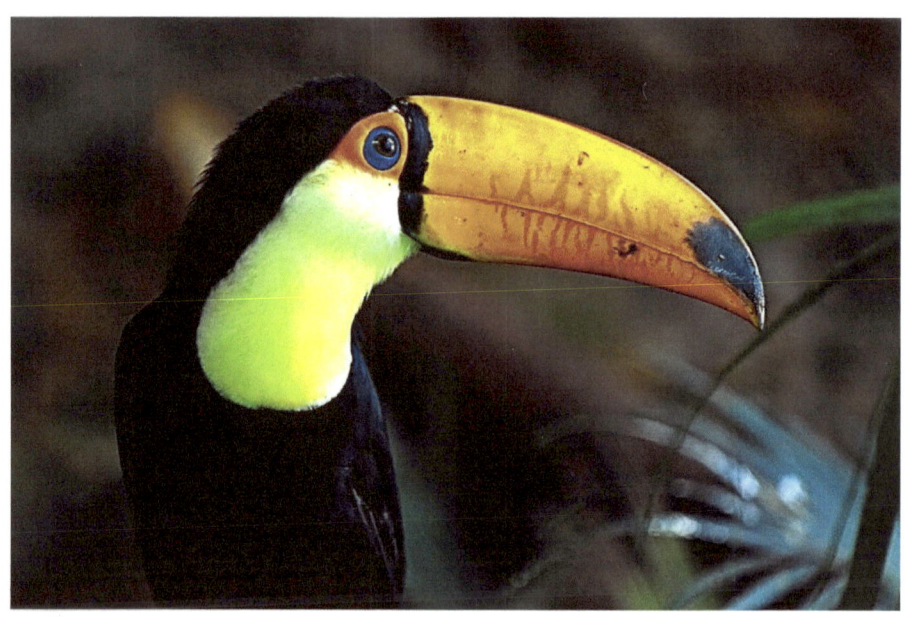

Toucan.

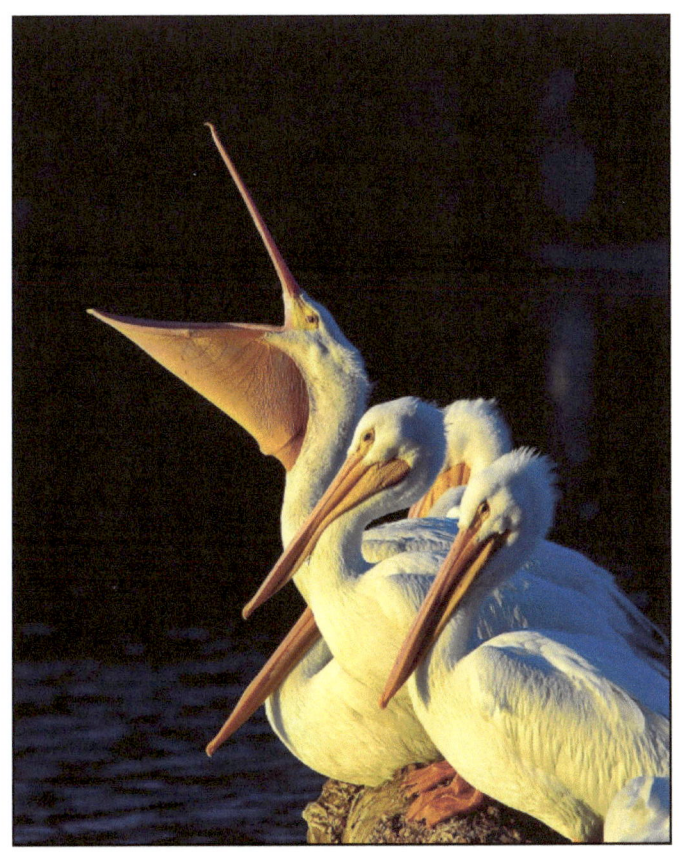

American White Pelicans at sunset in White Rock Lake, Dallas.

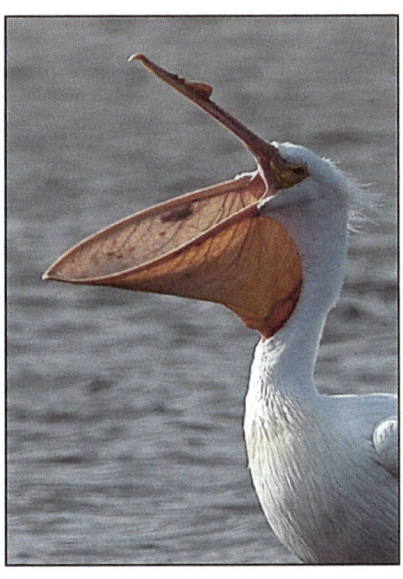

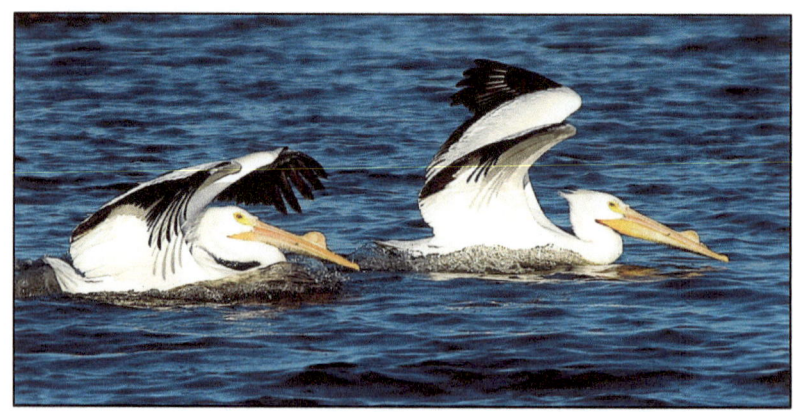
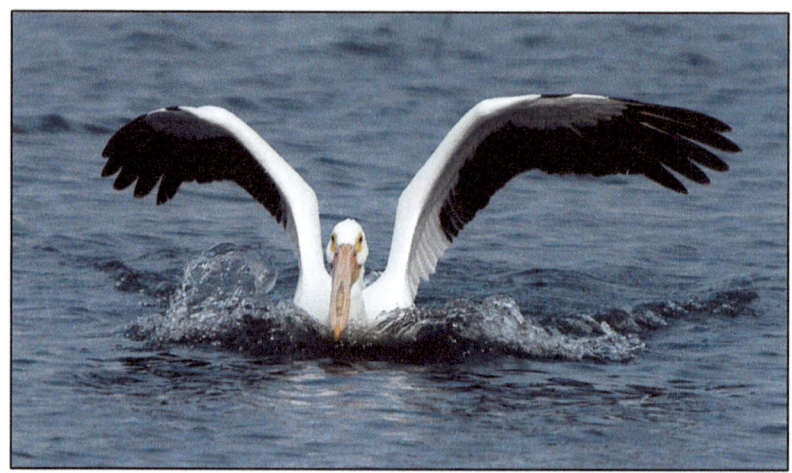
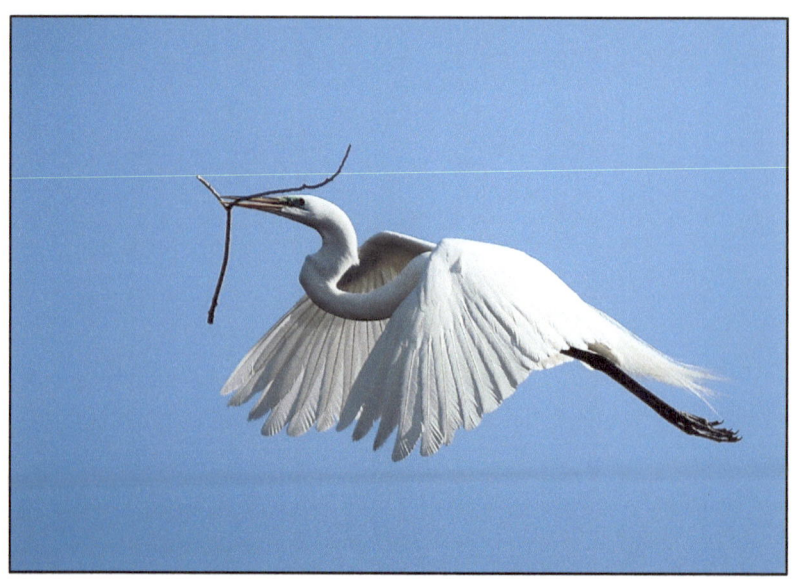

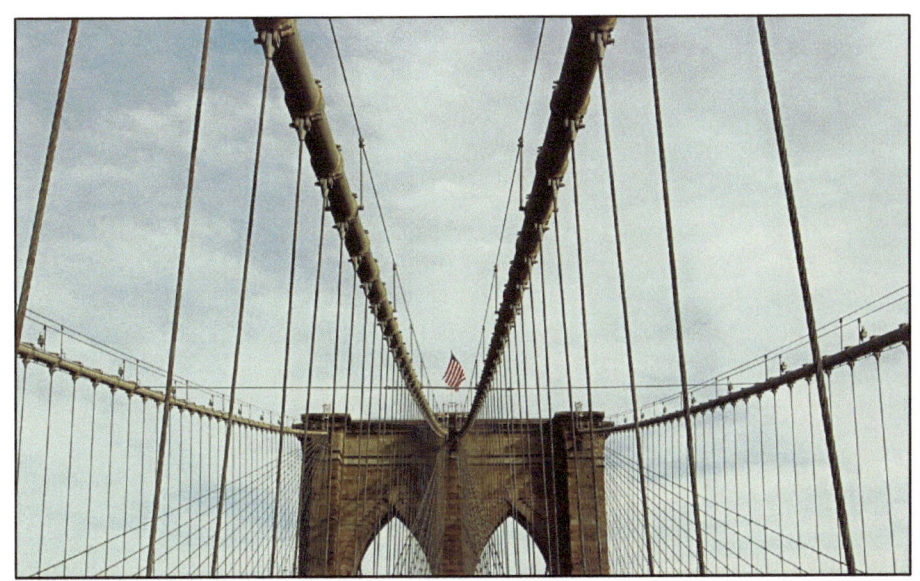

Brooklyn Bridge.

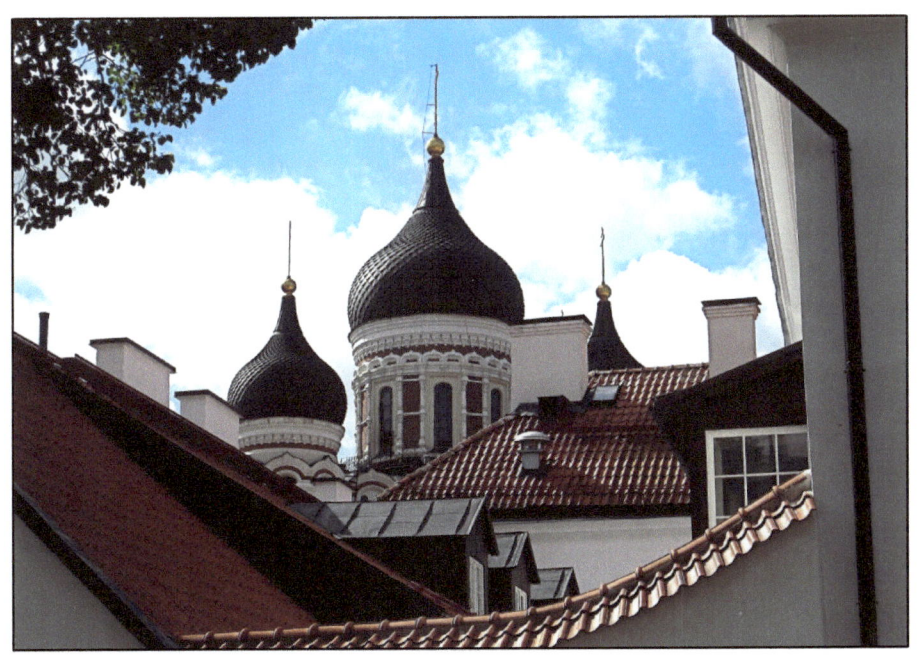

Baltic Cruise.

Portugal.

State fair.

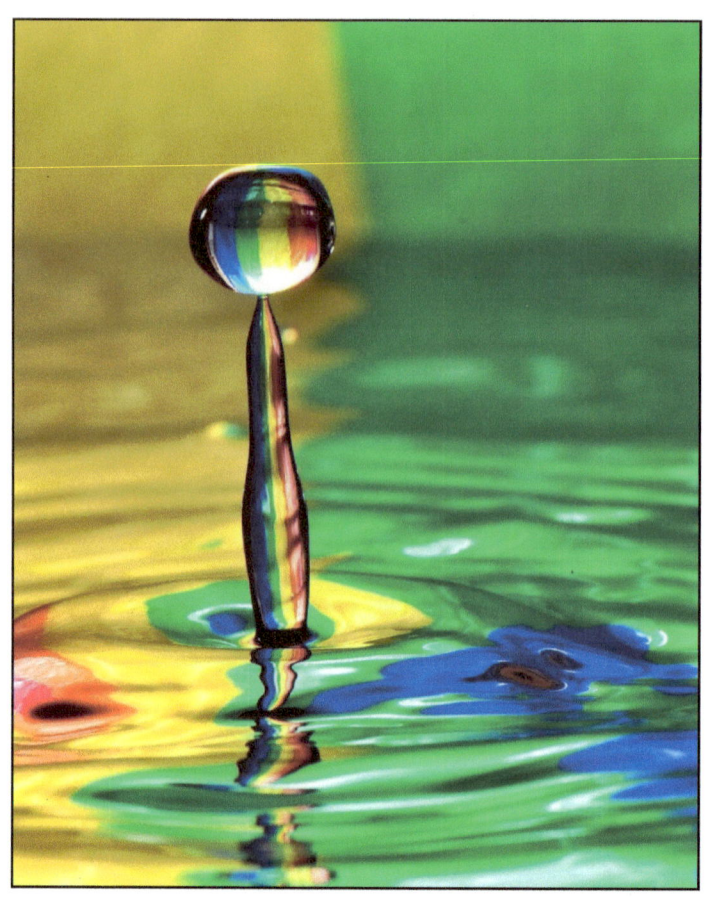

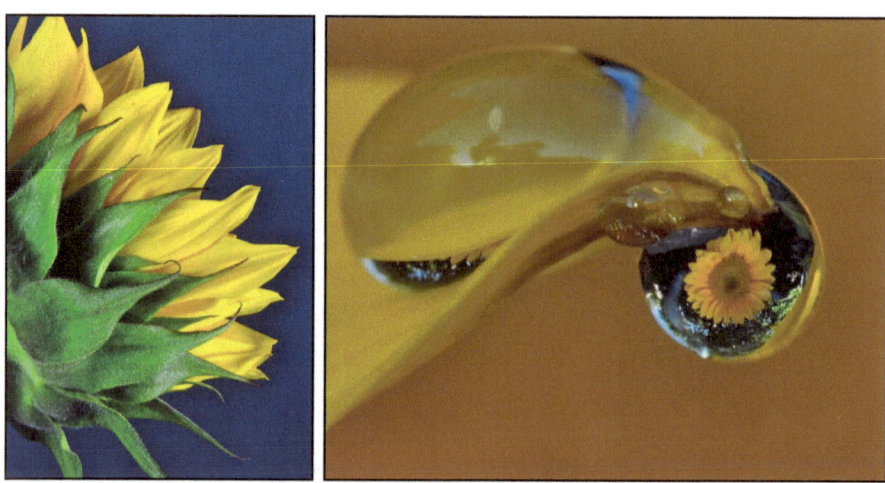

Sunflower septals close-up and sunflower image on a water droplet.

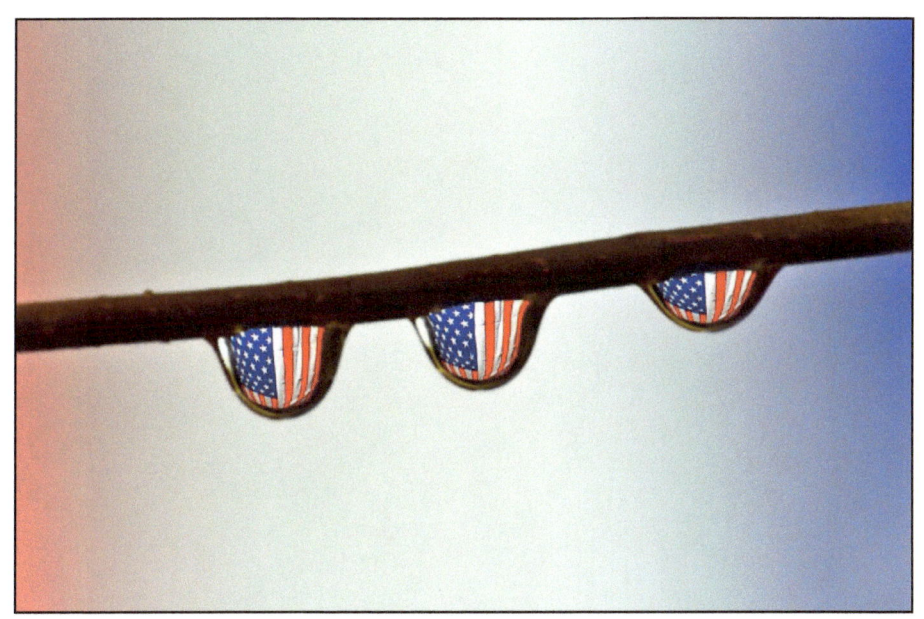

Old Glory reflection.

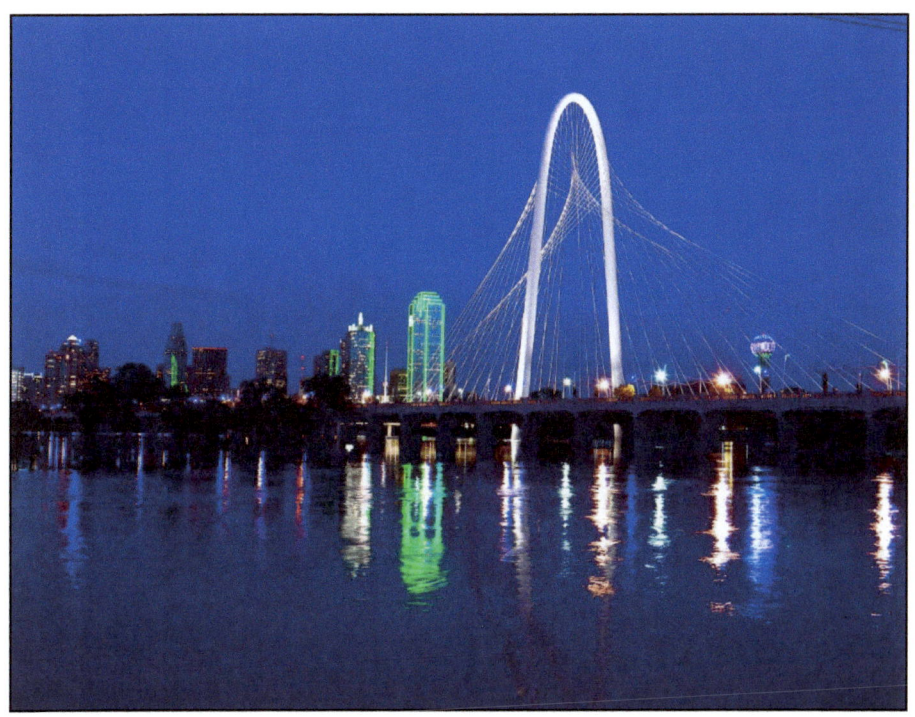

Margaret Hunt Hill Bridge over the Trinity River in Dallas, Texas.

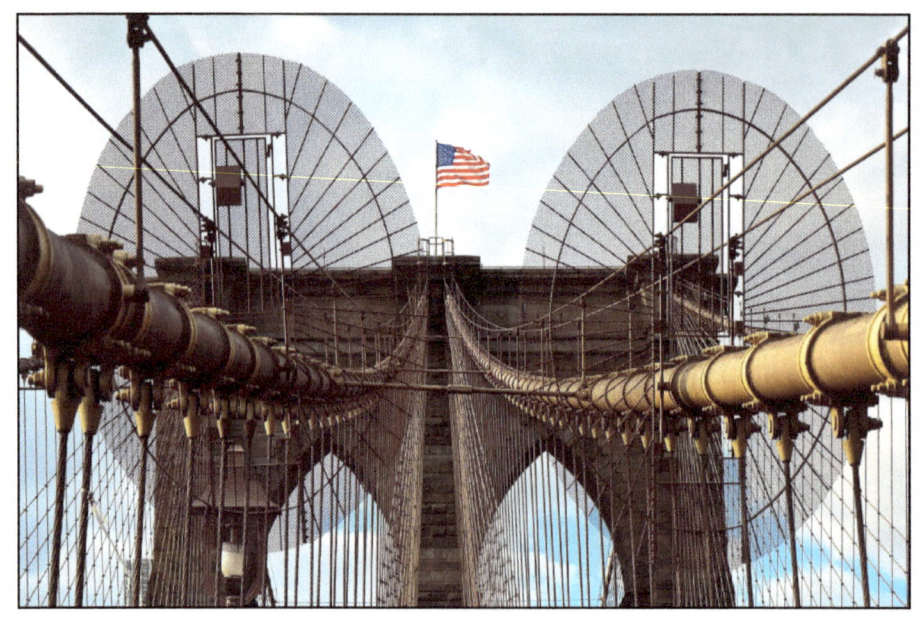
Brooklyn Bridge.

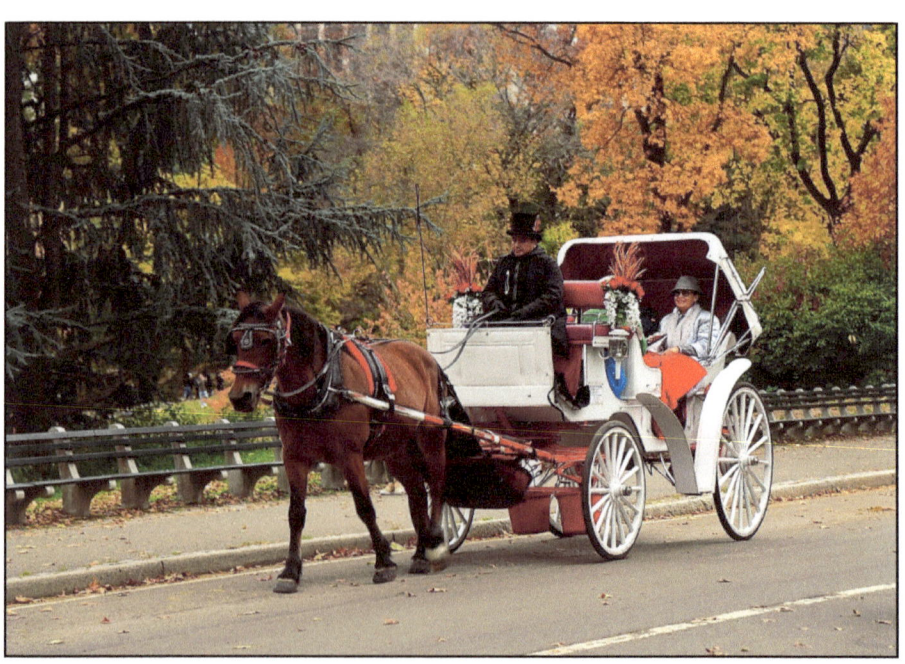
Autumn at Central Park.

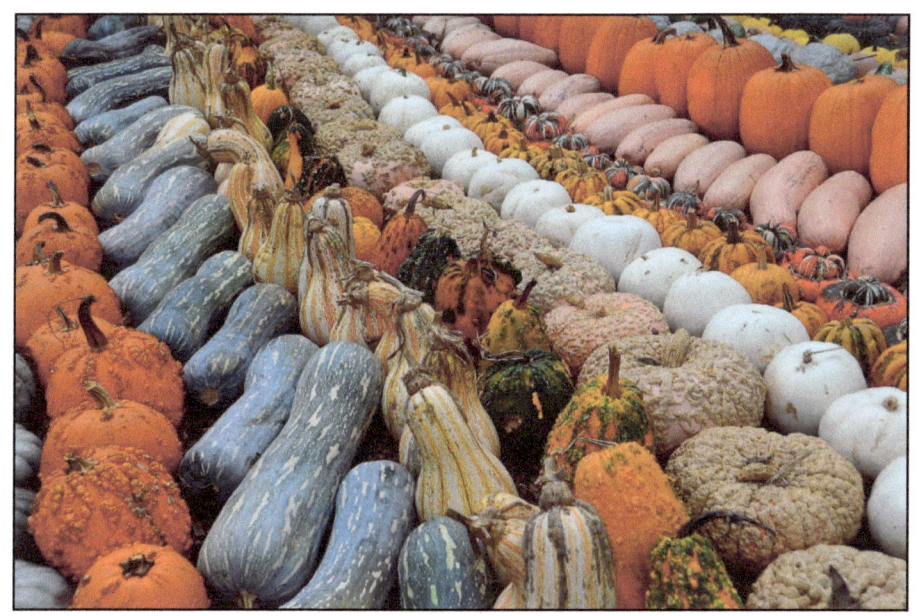

Pumpkins at the Dallas Arboretum.

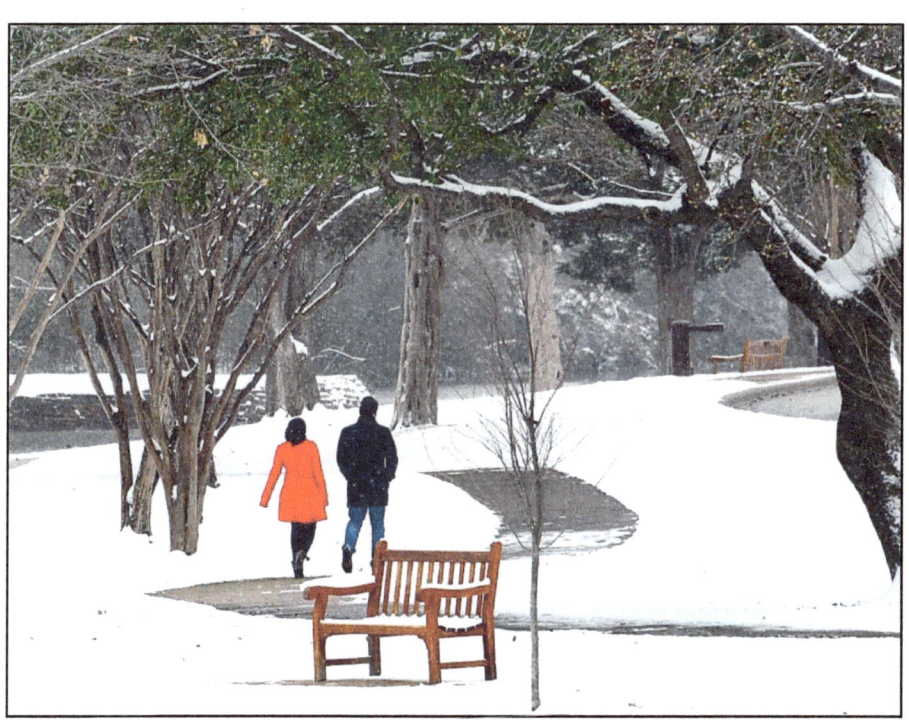

Snow Day at Lakeside, Highland Park, Texas.

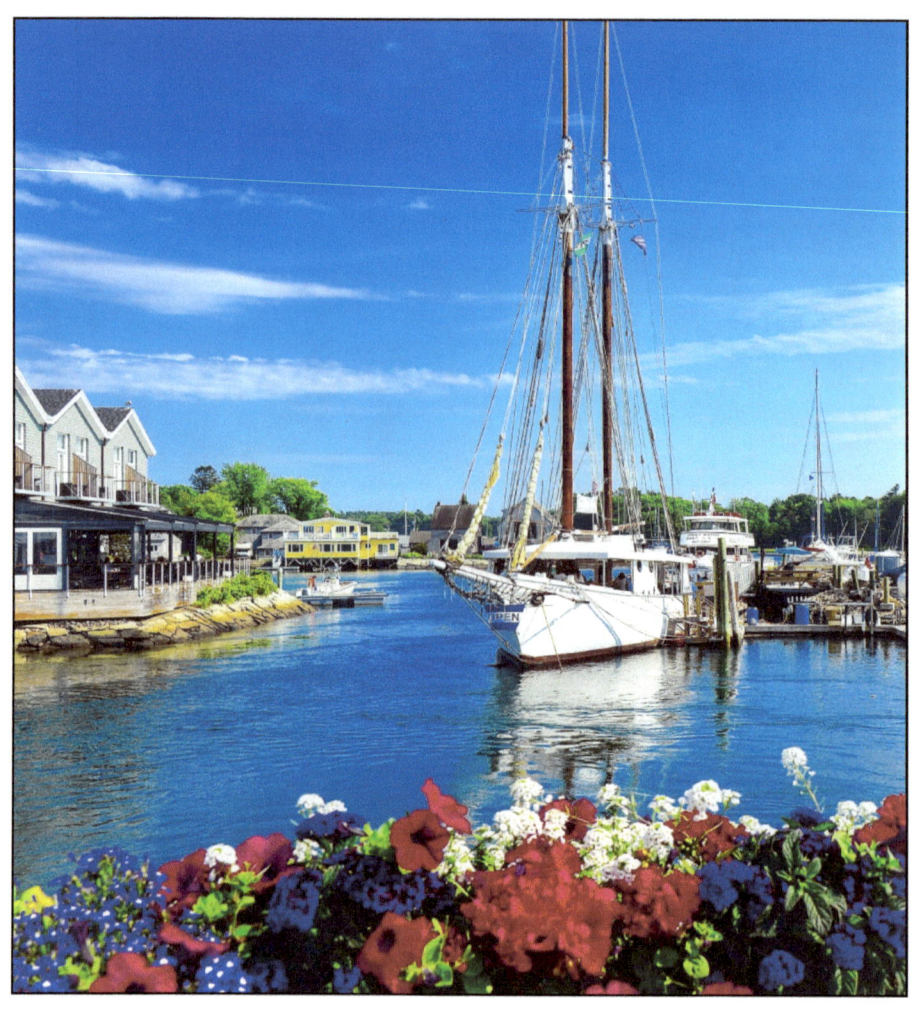
Summer in Kennebunkport, Maine.

Barry Uhr, MD

Dr. Uhr (1939–2010) was an ophthalmologist at Baylor University Medical Center. He was interviewed for the journal in 2009.

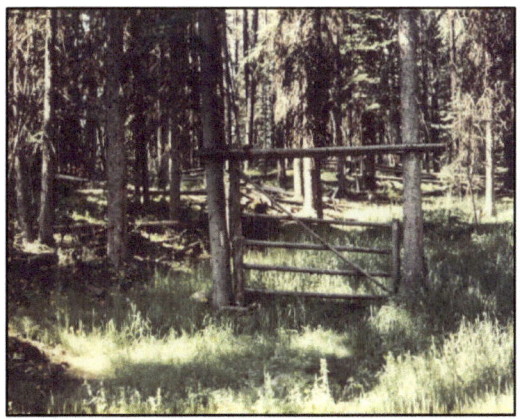

The Gate

There lies within our hearts and minds
Some thoughts we've never spake
Of ebb and flow, of here and there,
Perhaps a golden gate.

Some say 'tis but a hazy dream;
Others swear it's true
Standing in the pristine woods
This one is seen by few.

Some travelers go around the gate;
Others pass right through.
How to reach the other side
Seems clearly up to you.

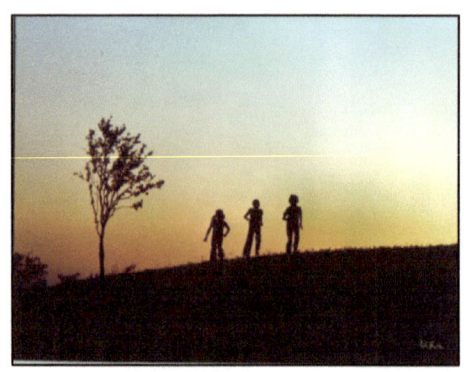

Silhouette

As in a mirror shining
We see reflected waves,
So in the eye's refraction,
We concentrate the rays.

Still senses do deceive us
In reverberating ways,
And angles of reflection
Carousel our nights and days.

Dimension needs perception,
Judgment more than light.
Position alters what we see,
Darkness or the light.

In wisdom hast it been
 ordained,
Our limits well defined,
'Tis only in our dreams that we
Might cross horizon's line.

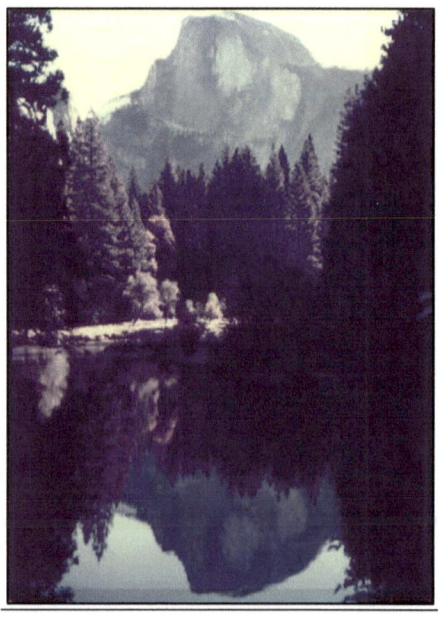

Crowned

A massive granite mountain
Straining toward the sky:
Its soft subdued reflection
Captivates the eye.

Centrally an arbor grows
In this ambient scene,
Not ensconced in shadows
And with a humble lean.

Though not imbued with
 grandeur
Or crowned with lofty height
Content to share the splendor
While reaching for the light.

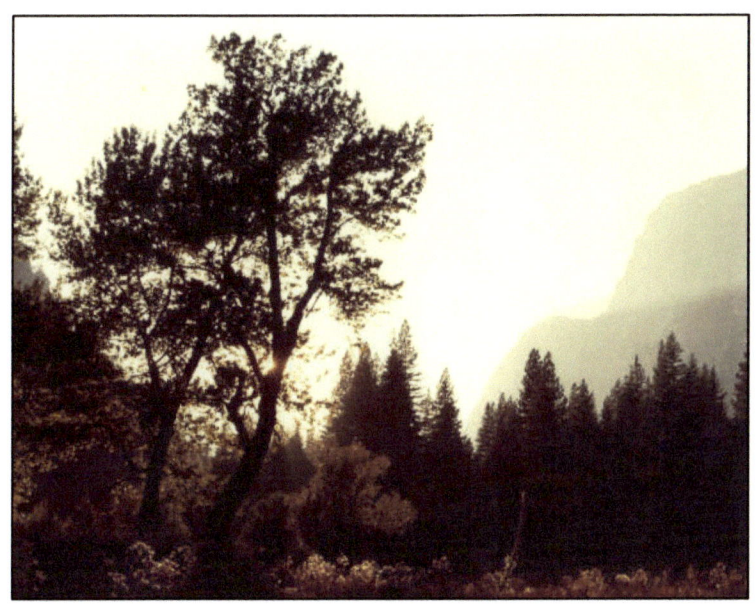

Yosemite

In solitude and grandeur,
Bending from on high,
Massive cliffs or granite
Fade in sunset's sky.

Evening's hush and stillness,
O'er valley's tousled floor,
Bring shadows creeping steadily
To close the golden door.

Those feelings last a moment
In pure reality,
And memory hast recorded
For all eternity.

Surely there are more to come
And others to observe,
Yet none will be its equal,
Our senses for to serve.

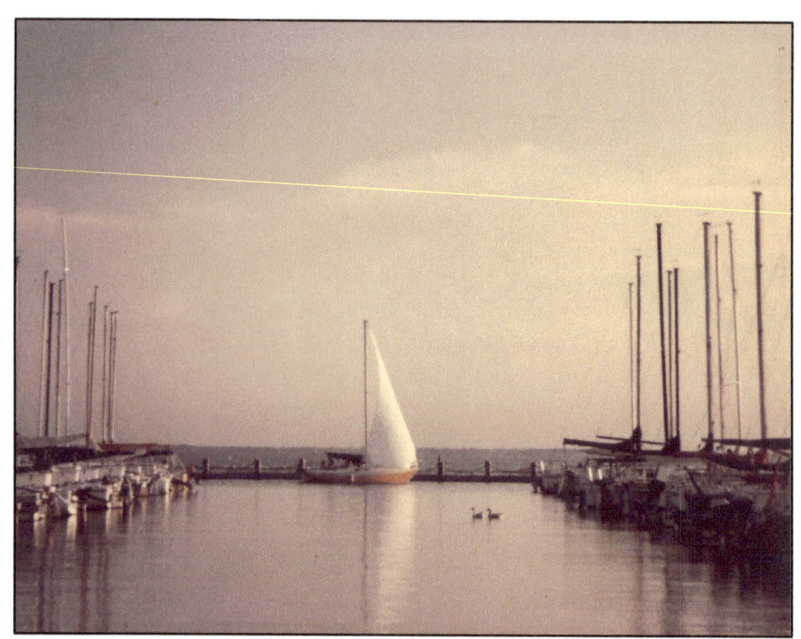

Harbor

In a gentle harbor
Glassy waters lie,
Reflecting many images
Beneath a velvet sky.

Beyond the jetty waves rejoice,
Where freely they can shout,
And dance in undulation
Outside the low redoubt.

So gaze on, shackled dreamer,
Into sea and sky and air,
Stifle not your inner self
But find your freedom there.

Sail on toward the setting sun,
Grasp at mist and clouds.
Dreams are born in such a place
Where thoughts discard their shrouds.

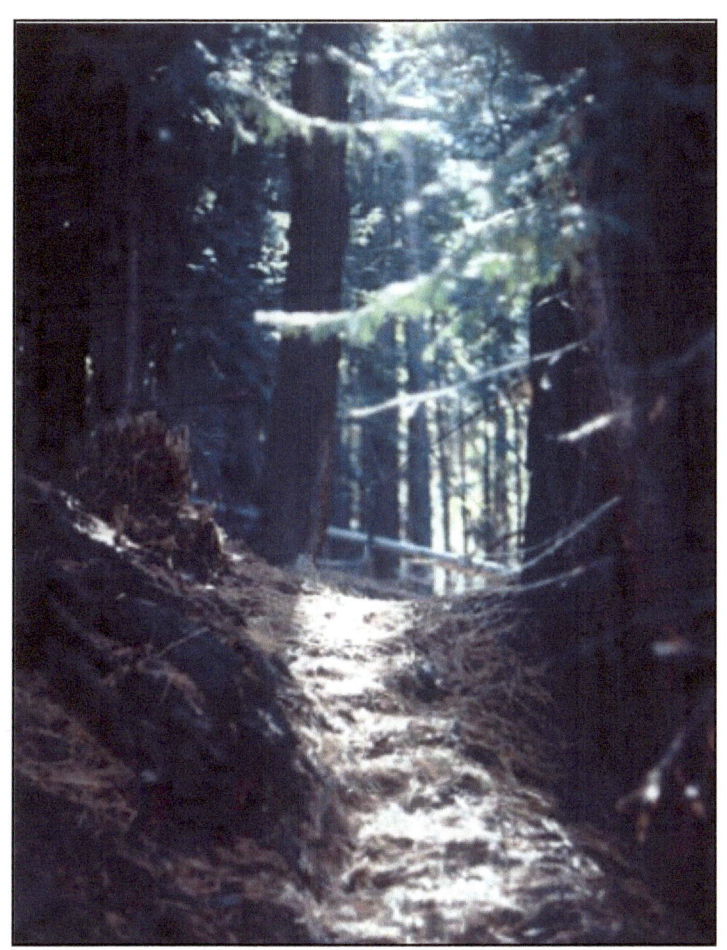

Paths

Some paths are lighted
And never even trod.
Others worn by many steps
Are barren, lifeless sod.

As both may reach a common goal,
What difference twixt, you say?
Inquires the wise and singular sage,
Say you the light along the way?

About BUMC Proceedings

As of 2021

- Indexed in PubMed, with full text freely available through PubMed Central
- Receives over 3.5 million Internet views and downloads on PubMed Central a year
- Has a print circulation of 6500
- Is one of a few institutional journals, similar to *Mayo Clinic Proceedings* and *The Cleveland Clinic Journal of Science and Medicine*
- Has a 53% acceptance rate, with an average of 23 days to first decision
- Publishes nearly half of its articles from authors outside of Baylor Scott and White Health
- Published by Taylor & Francis

www.BSWHealth.med/Proceedings

https://www.tandfonline.com/toc/ubmc20/current

https://www.ncbi.nlm.nih.gov/pmc/journals/302/